2 3 **4** 5 6 7 8 9 10

THE TECH SET

Ellyssa Kroski, Series Editor

Library Videos and Webcasts

Thomas Sean Casserley Robinson

Neal-Schuman Publishers, Inc.

New York London

Published by Neal-Schuman Publishers, Inc.
100 William St., Suite 2004
New York, NY 10038

Published in cooperation with the Library Information and Technology Association, a division of the American Library Association.

Printed and bound in the United States of America.

The paper used in this publication meets the minimum requirements of American National Standard for Information Sciences—Permanence of Paper for Printed Library Materials, ANSI Z39.48-1992.

ISBN: 978-1-55570-705-7

This book is dedicated to my wife, Susie.
Without her love and support this book would not have been possible.

CONTENTS

Don't miss this book's companion wiki and podcast!

Turn the page for details.

THE TECH SET is more than the book you're holding!

All 10 titles in THE TECH SET series feature three components:

1. the book you're now holding;
2. companion wikis to provide even more details on the topic and keep our coverage of this topic up-to-date; and
3. author podcasts that will extend your knowledge and let you get to know the author even better.

The companion wikis and podcasts can be found at:

techset.wetpaint.com

At **techset.wetpaint.com** you'll be able to go far beyond the printed pages you're now holding and:

- ▶ access regular updates from each author that are packed with new advice and recommended resources;
- ▶ use the wiki's forum to interact, ask questions, and share advice with the authors and your LIS peers; and
- ▶ hear these gurus' own words when you listen to THE TECH SET podcasts.

To receive regular updates about TECH SET technologies and authors, sign up for THE TECH SET Facebook page (**facebook.com/nealschumanpub**) and Twitter (**twitter.com/nealschumanpub**).

For more information on THE TECH SET series and the individual titles, visit **www.neal-schuman.com/techset**.

FOREWORD

Welcome to volume 4 of The Tech Set.

Library Videos and Webcasts is a one-stop manual for how to create knock-out videos for your library from marketing shorts to new service announcements, library tours, author interviews, instructional screen-casts, and more. Library video guru Sean Robinson takes you by the hand and walks you through how to do everything from building your own microphone stand to planning a shooting sequence. This book is jam-packed with project ideas, video techniques such as using dollies during filming and employing different camera angles, and post-production guidance for video and audio compression. Each project discussed reflects the fact that this outstanding book was written specifically with the librarian in mind, including filming patron-created content, producing a video annual report, and even how to save money by creating your own lighting kits and equipment.

The idea for The Tech Set book series developed because I perceived a need for a set of practical guidebooks for using today's cutting-edge technologies specifically within libraries. When I give talks and teach courses, what I hear most from librarians who are interested in implementing these new tools in their organizations are questions on how exactly to go about doing it. A lot has been written about the benefits of these new 2.0 social media tools, and at this point librarians are intrigued but they oftentimes don't know where to start.

I envisioned a series of books that would offer accessible, practical information and would encapsulate the spirit of a 23 Things program but go a step further—to teach librarians not only how to use these programs as individual users but also how to plan and implement particular types of library services using them. I thought it was important to discuss the entire life cycle of these initiatives, including everything

from what it takes to plan, strategize, and gain buy-in, to how to develop and implement, to how to market and measure the success of these projects. I also wanted them to incorporate a broad range of project ideas and instructions.

Each of the ten books in The Tech Set series was written with this format in mind. Throughout the series, the "Implementation" chapters, chock-full of detailed project instructions, will be of major interest to all readers. These chapters start off with a basic "recipe" for how to effectively use the technology in a library, and then build on that foundation to offer more and more advanced project ideas. I believe that readers of all levels of expertise will find something useful here as the proposed projects and initiatives run the gamut from the basic to the cutting-edge.

After watching the Allen County Public Library's award-winning *Library Zombies* video at the 2008 InfoTubey Awards, I knew that Sean Robinson needed to write down everything he knew about video production for the rest of us. And that's exactly what he did in *Library Videos and Webcasts*—far exceeding my expectations in the process. If you want to learn all there is to know about how to create exciting, innovative videos for your library from start to finish, this is the book for you.

Ellyssa Kroski
Information Services Technologist
Barnard College Library
www.ellyssakroski.com
http://oedb.org/blogs/ilibrarian
ellyssakroski@yahoo.com

Ellyssa Kroski is an Information Services Technologist at Barnard College as well as a writer, educator, and international conference speaker. She is an adjunct faculty member at Long Island University, Pratt Institute, and San Jose State University where she teaches LIS students about emerging technologies. Her book *Web 2.0 for Librarians and Information Professionals* was published in February 2008, and she is the creator and Series Editor for The Tech Set 10-volume book series. She blogs at iLibrarian and writes a column called "Stacking the Tech" for *Library Journal's* Academic Newswire.

PREFACE

Through today's video technology, there is a new way to communicate with your patrons 24 hours a day, 7 days a week, whenever and wherever they are. It may sound intimidating, but this book is written to show you, step by step, just how easy it is for your library or institution to create and use this new technology.

Equipment costs have fallen and video software has advanced to the point that expert knowledge is not necessary to produce high-quality videos. Libraries are creating everything from videos for advertising new services to book reviews created by their teen patrons. Libraries are filming weekly video blogs informing patrons about upcoming programs and are offering short instructional videos ranging from such topics as how to pay library fines and bills online to using new Web technologies.

Online video is a simple means to communicate directly with your patrons. Whenever or wherever they are, they can see what your library looks like, thinks like, and has planned. And they can learn how to use your services at their convenience. This allows you to say it once but be heard many times. It enables your patrons to become self-sufficient and reduces the staff time needed to explain services and events. In these economic times, being able to add services to your library while freeing up staff to handle additional responsibilities makes this very attractive and practical.

▶ ORGANIZATION AND AUDIENCE

Library Videos and Webcasts will lead readers step by step through the video creation process. Chapter 1 begins with video and Webcast basics, such as identifying and gathering everything you will need to get

started, including funding. Chapter 2, "Planning," covers getting buy-in from staff and the ABCs of looking for ideas and inspiration and preparing to create a video. Chapter 3, "Implementation," covers how to create a basic video, including basic and advanced quality techniques, along with how to create a collection of library videos geared toward a variety of specific subjects, such as marketing, service announcements, video tours, interviews, annual reports, and instructional screencasts.

And let's not forget marketing! Chapter 4 covers how to get the word out, how to develop a brand, and how to use video hosting services such as YouTube and other social networks. Chapter 5, "Best Practices," features a list of inspiring and creative library videos as well as practical tips and advice, and thoughts on the creative process. Finally, Chapter 6 explains how to measure the success of library video implementation by tracking views and usage of your videos with popular and, often, free Web metric tools.

Library Videos and Webcasts takes a comprehensive look at videos, not only the production process, but also the planning and creative aspects. It is primarily for librarians; however, anyone who wants to learn anything, from an introduction, to making a video, to animation and advanced filming and editing techniques will find this book helpful. People completely new to this technology will be provided with enough guidance to feel confident that they can make a high-quality video, while those who may already have knowledge in video technology will be inspired to incorporate more creative techniques and ideas.

I wrote *Library Videos and Webcasts* to show you how easy and inexpensive it can be to start creating your own videos to inform your staff and library patrons. I hope that, after reading this book, you are as inspired to create videos as I continue to be.

ACKNOWLEDGMENTS

I want to thank my wife, Susie. Her willingness to review, proof, and provide suggestions was invaluable. Her belief that I could actually do this was a great comfort when I had doubts. Her willingness to put our lives on hold and tolerate my single-mindedness reminds me yet again that I am a lucky man.

I cannot thank Ellyssa Kroski enough. She had the courage and faith, having never met me, to ask if I would be interested in writing this book. She then had the patience and kindness of spirit to hold my hand and guide me through the process. I am grateful for this opportunity and her assistance. It has been a pleasure working with her on the project.

Also, I must thank Amy Knauer of Neal-Schuman, who worked with me hand in hand as the book approached production. She committed herself to the vision I had for my book and worked tirelessly to ensure that it was realized. And for that I am extremely grateful.

Finally, to the person who is the reason I was able to start creating videos, Kay Gregg. I would like to thank her for listening to all my crazy ideas and having the self-discipline to demand a script and storyboard before agreeing to sign on. All the work that I have created would not have been possible without her expertise and insight.

▶1

INTRODUCTION: LIBRARY VIDEO AND WEBCAST BASICS

- ▶ **Creating a Shopping List**
- ▶ **Basic Hardware**
- ▶ **Software Options**
- ▶ **Do-It-Yourself Instructions**
- ▶ **How to Get Equipment on a Tight Budget**

▶ CREATING A SHOPPING LIST

It's decision time! What do I absolutely need? What do I want? How much money do I have to spend? Tools of the trade include camera, microphone, lights, computer, video and audio editing software, tripod for the camera, microphone stand, portable lighting structure, and headphones. It seems like a lot, but with some bargain hunting you should be able to get everything you need from about $100.00 for a Webcam setup, to $750.00 for a low-end starter kit, to $3,500.00 for a full setup.

▶ BASIC HARDWARE

Cameras

The choices can be overwhelming and, at times, intimidating. Here are the questions you should ask.

Will I be purchasing a professional or consumer-grade camera? Entry-level consumer cameras cost $250.00–$350.00, while professional cameras start at $1,500.00 and go up from there. A consumer-grade camera does everything you should need to get started. You have two

Camera Setups and Associated Costs

Webcam starter kit (note that many new laptops have Webcams and microphones):

- ▶ 1 Laptop computer, $500.00–$700.00
- ▶ 1 Webcam, $50.00–$100.00
- ▶ 1 Microphone, $20.00–$50.00

Barebones starter kit (if you have a computer, you can use that for your video editing platform):

- ▶ 1 Camera, $150.00–$500.00
- ▶ 1 Microphone, $100.00 (I recommend the handheld because it is the most versatile)
- ▶ Editing software that comes with your computer, free
- ▶ Build your own lighting kit, $100.00
- ▶ Tripod, $50.00
- ▶ Total: $500.00–$750.00

Full setup:

- ▶ 1 Computer with high-end graphics, $1,400.00
- ▶ 1 Camera, $700.00
- ▶ 1 Handheld microphone, $100.00
- ▶ 1 Shotgun microphone, $100.00
- ▶ 2 Lavalier microphones, from $150.00
- ▶ XLR audio converter, $200.00
- ▶ Video editing software, $300.00
- ▶ Build your own lighting kit, $100.00
- ▶ Screencasting software, $300.00
- ▶ File conversion software, $50.00
- ▶ Tripod, $50.00
- ▶ Boom microphone stand, $50.00
- ▶ Total: $3,500.00

options: an SD (standard-definition) or an HD (high-definition) camcorder. Do you want a higher quality image? Then go with the HD camcorder. If you have a small budget and want to get started inexpensively, then choose SD.

What features will I need? You will need a good zoom lens, preferably 10× or greater. Most cameras in the $500.00–$700.00 range have this zoom capacity. A zoom lens allows you to capture a wide variety of shots, from close-ups to full scenes. You will need to have a microphone and headphone plugs. Low-quality audio makes for low overall video quality. The hybrid class of HD camcorders allows you to store your video on an SD card or in the built-in hard drive. The Sony Handycam HDR-SR12 is an excellent example of this type of camera.

CCD (charged couple device) and CMOS (complimentary metal-oxide semiconductor) convert light into electrons. CCD captures a higher quality image but requires more power. CMOS is catching up with image quality and uses far less battery power.

Another concern is the format that the camera uses to record the digital video. AVCHD (audio video compression for HD) is a new format and allows you to record in both SD and HD. Cameras will record in all kinds of formats. The important thing is that the format you record in should be able to be imported into your video editing software. If you don't get a camera that can natively import into your editing software, you will need to transcode the file into a format that can be accepted. It is very useful if your camera can record in progressive mode, either 720p or 1,080p. If it just records in interlaced mode then you are going to have to deinterlace. Your video editing software can do this, but it will add another step. Progressive mode just means that the image is displayed at once, while interlaced displays half the images on every odd line and then the other half on every even line, and this will produce a flicker on a LCD screen. YouTube does deinterlace for you when doing the uploading and encoding, but you will want to do this before you upload to any online service to improve the upload speed and ensure that the video is deinterlaced. Again, if your camera can record in progressive mode, you do not need to worry about deinterlacing.

The Mino HD is a tiny flip video recorder (see Figure 1.1). The HD model retails at $229.00, and the low-end flip video retails for $129.00. Having tested the Mino HD, I was amazed with the picture quality. It will record 60 minutes of video and has 1,280 × 720 resolution. It has a built-in microphone and a tripod mount. It will give you two hours of filming before it needs recharging. It produces an amazing picture for the size and simplicity of the device, and the flip-out subport makes it simple to upload and edit your files.

The Vado HD is another tiny flip video recorder (see Figure 1.2). It has a wide-angle lens, and, when compared to the Mino HD, it is the hands-down winner and retails for about the same amount. It has a two-inch LCD screen and eight gigabytes of memory and will record two hours in HD. It has a tripod mount and a built-in microphone and speaker. It also has an HD multimedia interface (HDMI) and a standard composite output video out slot. The HDMI cable comes with the Vado, but you would need to purchase the composite cable separately. It has a digital zoom and a removable lithium ion battery so you can keep a spare. It saves files in the .avi format instead of the preferable .mp4.

▶ Figure 1.1: Mino HD Flip Camera

▶ Figure 1.2: Vado HD Flip Camera

Web Cameras

The Logitech QuickCam Pro 9000 lets you capture and broadcast from your laptop (see Figure 1.3). It has a two-megapixel sensor that will shoot video at 1,600 × 1,200 resolution. It is optimized for the Windows platform. If you are a Mac user, the Logitech QuickCam Vision Pro is a good choice. This camera is marketed for the Mac but will also work on the Windows platform. If you are looking for a slightly lower-end camera, the Logitech QuickCam Communication Deluxe is a good choice, and Creative has a Live Cam Series, which will give you a number of pricing and configuration options. Also, many laptops and some desktops already have a built-in Webcam. Over the years I have had Web cameras from both Logitech and Creative in the $30.00–$100.00 range. Each of these companies produces solid products. The two main issues for me have been mounting the camera and video quality. I prefer a camera that clips to the top of a monitor so that I can adjust it without having to fiddle for a couple of minutes to get everything aligned correctly.

Red Cameras are on the other end of the spectrum (see Figure 1.4). These cameras were used to make such films as *Angels and Demons* and *The Bourne Identity*. They are professional cameras that generally start in the $20,000 price range, but this year a new entry-level camera with

▶ Figure 1.3: Logic QuickCam Pro 9000

▶ Figure 1.4: Red Camera

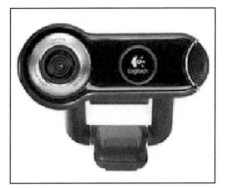

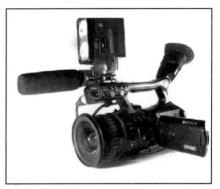

a pixel density ten times greater than traditional cameras was released that starts at $3,000.00.

Quick Tip

Check out YouTube and search on each of the camera models you are interested in. People have uploaded test video for most models. Study them to get a clear idea of the quality of footage you will be able to capture and post to the Web.

Microphones

A camera will generally have a built-in microphone, and you might be tempted by your budget restraints to think that this is sufficient. Capturing audio is all about proximity. How close is the microphone to the subject? In some instances, when a subject is close to the camera (by this I mean two to three feet), you can use the camera microphone. Anything farther away and you are going to start picking up noise from reflected surfaces and the surrounding area.

Before we look at microphones, let's take a look at XLR adapters for the microphones. Commercial cameras come with a mini microphone input, and most microphones have an XLR connector. You are going to need to buy an XLR adapter to take advantage of these microphones. They are not too expensive and will allow you to plug in a number of microphones. BeachTek makes a DXA-2S Dual XLR adapter that connects to the tripod thread at the bottom of your camera, and then the adapter has a thread that you can attach to your tripod. This adapter will allow

you to plug in two microphones. Figure 1.5 shows a Rode XLR to mini input. The converter cables cost about $10.00.

The three basic microphone options are handheld, shotgun, and lavalier (lapel). You can go wired or wireless, depending on your need and budget. It's a good time to think about what you are going to be filming. Will your subject be moving around? Most of the time in the library videos I have created there are not a lot of chase scenes and explosions. It is generally one or two people standing in front of a camera talking, and I find lavalier microphones to be the most useful.

Handhelds are a great option too. Good audio is about proximity, and a handheld microphone can be a good solution. The disadvantage is the look. If you are going for the "reporter on the street" look, then it is perfect. Another disadvantage is that it ties up the subject's hand, and, unless he or she is already comfortable with the microphone, it is probably going to look a little awkward. This type works really well for voiceovers and postproduction work. Shure makes an inexpensive handheld microphone in the $50.00–$100.00 range.

Lavalier microphones are small and attach to the actor's clothes, about six inches from the face (see Figure 1.6). This type of microphone is great for making instructional or promotional videos for your library. They are either omni- or unidirectional. Omnidirectional will pick up surrounding noise, whereas unidirectional will just pick up sound from the direction that it is pointed. Radio Shack sells a very nice, inexpensive omnidirectional microphone for $45.00–$50.00, and it has a mini connector so that it will plug directly into your camcorder.

▶ Figure 1.5: XLR to Mini Adapter Cable

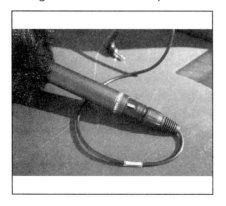

▶ Figure 1.6: Lavalier Microphone

The disadvantage with the Radio Shack microphone is that it is omnidirectional, but you cannot beat the cost. Sony makes a very nice unidirectional microphone, the Sony ECM 66B, but it retails for about $300.00. We have used the lavalier microphones for interviews, promotions, and instructional videos. Remember that lavalier microphones need to point upward toward the speaker's face. One trick if you are placing the microphone under a layer of clothing is to wrap the microphone with moleskin. This will stop the rustle of fabric.

Shotgun microphones are unidirectional. Often they are used as a boom microphone and are placed over the actors' heads but out of the shot. When would you use a boom microphone rather than a handheld or lavalier? Boom microphones are used when you have a couple of people talking and you want to capture the natural sound of the conversation. A shotgun microphone can be used with a lavalier or handheld to get a better audio quality. Shotgun microphones can also be attached to the top of your camera and will outperform the built-in microphone. You can find shotgun microphones for under $100.00.

USB Microphones

This new class of microphone is an excellent solution for podcasting and voiceovers. USB microphones plug directly into your computer and can be used with any audio capturing software, such as Audacity or GarageBand. The prices range from $100.00 to $300.00. The Alesis USB podcasting kit is an excellent product.

Tripod Stands

You need a tripod for your camera. Tripods allow you to set your camera angle correctly. A tripod gives you a rock solid shot and really separates professional video production from home videos. Look for sturdy feet that will work on both smooth and rough surfaces. Your tripod will need to work both indoors and outdoors, have easily adjustable legs, have a good locking mechanism, and be lightweight. Get a tripod that extends to eye level. The Velbon CX-690 DLX Tripod is a great starter tripod and is in the $50.00–$60.00 range. It extends to five feet, which will work for almost all situations.

Microphone Stands

The three types of microphone stands are the boom stand, the straight vertical stand, and the table stand. The boom stand is probably the

most versatile and will work with a shotgun microphone. There is no need to buy a table stand, as you can easily make one from a coat hanger and save a couple of bucks. Another cost saver is to make a portable boom microphone pole from a retractable painter's pole. A reasonable boom stand can be purchased for about $50.00.

Headphones

Headphones are a must because this is the only way you are going to be able to hear the audio levels that your microphones are picking up. Headphones will allow you to make changes to microphone placement and to get the audio quality you want. You do not want to hear other noise such as wind and clothing rustle as you tape.

Headphones come in three types: circumaural (over the ear), supraaural (on the ear), and ear buds (in the ear). Get the circumaural. They block the surrounding sounds and will let you hear clearly what the microphones are picking up. Sony puts out a really nice range of headphones for about $30.00 to $50.00. Also get an audio extension cord. This will allow you to walk around with your headphones on and make microphone adjustments.

▶ SOFTWARE OPTIONS

Video Editing

There are a number of software packages to choose from, depending on your needs and budget. Windows comes with a free software package called Movie Maker. It allows you to do basic video editing. Sony Vegas Movie Studio runs on Windows, offers a much larger range of editing options, and costs about $150.00. Wax is a free software tool that you can use to add effects to your video, and it also runs on Windows. On the Mac you can use iMovie or Final Cut Express, which costs about $250.00. I recommend using the free editing software that comes with your machine until there is something you want to do but are unable.

Other available video editing software includes Adobe Premiere Pro ($799.00), Avid Media Composer ($2,500.00), Corel Media Studio ($99.00), and Ulead's Media Studio Pro ($400.00). Whenever purchasing, ask for educational discounts.

Sound Editing

On Windows I have been using Audacity, and on the Mac platform I use GarageBand. One piece of equipment I find to be invaluable to audio recording, especially if I am using musical instruments to create a sound track, is the Fast Track m-audio recorder. This device allows you to plug in your XLR microphones and musical instruments to capture audio, and it retails for less than $100.00.

Screencasting

Screencasting allows you to capture and record what is happening on your computer screen and play it back at a later time. You can add an audio voiceover and many other visual effects such at titles and labels. It is often used in providing online computer instruction.

Wink is a free open source screen capturing software. It does everything you need to get started and was the first piece of screen capturing software that I used. After a couple months I outgrew Wink and purchased Camtasia Studio. What I love about screen capturing software is that you can incorporate your screen captures into your video. The feature makes it perfect for providing instructional videos to staff and patrons. What better way to teach someone how to do something than to show it to him or her? Camtasia retails for about $300.00 and runs on Windows. At this time Camtasia is not available for the Mac, but this is in development and should be in production soon. ScreenRecord is an inexpensive option at $15.95, if you just cannot wait or are looking for something a little less expensive.

File Conversion

Although a file conversion program is not a must-have item, being able to convert from one video format to another can be really convenient. On Windows, Movavi Video Converter is a low-cost (less than $30.00) video conversion application.

ffmpegX solved the problem on the Mac for me. This shareware package is a lifesaver. If you like it, pay the $15.00. It's worth it.

▶ DO-IT-YOURSELF INSTRUCTIONS

Build Your Own Microphone Stand

Start with a wire coat hanger, and bend it in the middle. Then fold the hook forward. You will need some pliers to tighten the hook so that it

fits tightly around the microphone (see Figure 1.7). This setup is re-markably stable. If you are worried about it moving, just wrap it lightly in duct tape.

Another option is the boom microphone stand. This can be built with a paint roller, pipe insulation, and a wire tie. You will need a hack-saw and a free half hour. You will need to notch the foam pipe insula-tion to get access to the on/off switch on the microphone and notch the back to allow the back of the microphone cord to come out freely (see Figures 1.8, 1.9, and 1.10).

Create Your Own Lighting Kit

The price range for a premade starter kit is approximately $300.00–$500.00. However, at a local hardware store you can purchase scoop lights and halogen lamps, all with clamps, which will allow you to at-

▶ Figure 1.7: Wire Coat Hanger Micro-phone Stand

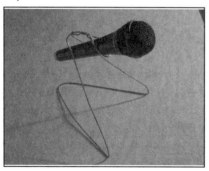

▶ Figure 1.8: Materials for Boom Micro-phone Stand

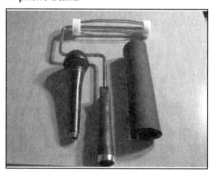

▶ Figure 1.9: Disassembled Paint Roller and Pipe Insulation

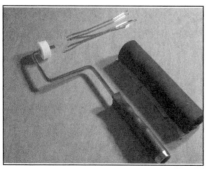

▶ Figure 1.10: Finished Boom Microphone Stand

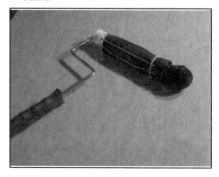

Advanced Do-It-Yourself Projects

Build Your Own Steadicam

A steadicam is a device for helping to steady a handheld camera. Converting your tripod into an ad hoc steadicam by holding it up can work in a pinch, but it's also possible to build a very inexpensive steadicam, using a vice grip or pliers and a power drill. For a material list, detailed instructions, and illustrations of the process, visit this book's companion wiki. Also included are instructions and illustrations for adding a U bracket to your steadicam that will enable you to capture low-angle shots, such as the one in Figure 1.11.

▶ Figure 1.11

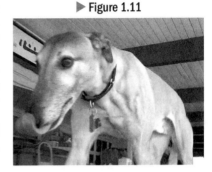

Build a Camera Jib for under $30.00

After I had made a couple of library videos, I found myself thinking about new camera angles. Wouldn't it be nice to get a high shot looking down on a subject, or how can I pan from a high vantage point to eye level? A camera jib is the answer. And like the steadicam, you can build an inexpensive one. Visit this book's companion wiki for detailed parts and materials lists, step-by-step instructions, and illustrations of the process.

tach them anywhere you want. I purchased three scoop lamps, three 300-watt bulbs, and one halogen lamp that came with a 300-watt bulb. A frosted shower curtain works as a diffuser to provide a soft wall of light. A Styrofoam board works well for a reflector. You may also need extension cords to get power to the lights. You can use tin foil on one side of the Styrofoam board to create a greater reflecting surface and on the scoop lights to shape the light that they emit. The total cost for the equipment I purchased (see Figure 1.12) came to approximately $70.00.

▶ Figure 1.12: Materials to Create a Basic Lighting Kit

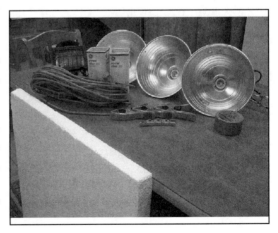

▶ HOW TO GET EQUIPMENT ON A TIGHT BUDGET

Tough economic times provide the opportunity to think creatively about funding. If you are a small library with a small budget or a large library that doesn't have the financial resources this year to put toward buying video equipment, what can you do? What you don't want to do is to let your vision and enthusiasm die.

Take all that creative energy and pour it into thinking of ways to find a solution to your funding problem. If your initial equipment proposal is rejected, ask the deciding group if it will allow you to come back with an alternative proposal. You'll get only one chance to come back and pitch your idea, so don't waste it. Create a proposal that asks permission to seek alternative funding through fund-raising. If the second proposal isn't accepted, make sure you include an option that will allow you to pursue this project but without funding or fund-raising.

So, how am I going to get the equipment I need for free? The first action is to make a plan. Here are the steps I would take. Don't just pick one, do them all!

1. **See what equipment your library has**. You may already have equipment you can use and don't realize it. Many laptops have a Webcam built in. Perhaps a department has ordered a Webcam for some other purpose. Perhaps your marketing or children's department already owns a camcorder or digital camera with video recording capabilities. Check all areas of your library to make sure there isn't any video equipment already lurking around that you can use.

2. **Ask for equipment and financial donations**. Create a story describing how the donations will be used. Talk about how Internet video is the new medium to communicate and share with the community. Talk about the programs you are offering and about training possibilities. This is about sharing your vision and motivating people into action. Put the request on your Web site and in your library newsletters.

3. **Check out Freecycle.org**. This Web site connects people who are looking for items with those who have items they no longer need. It is simple to create an account and search for your local area. The organization's mission is "to build a worldwide gifting movement that reduces waste, saves precious resources and eases the burden on our landfills while enabling our members to benefit from the

strength of a larger community." If you do receive equipment through this process, I strongly encourage you to find a way personally to give back.

4. **Borrow**. Nothing demonstrates and articulates your ideas better than a prototype. It is the classic chicken and the egg conundrum: I want to make a video, but I don't have a camera; if I had a camera, I could show you my ideas. Borrow some equipment. Ask your friends, and send out an all-staff e-mail. Some local schools, colleges, or other not-for-profit organizations may be happy to allow you to borrow or come use their equipment. Talk to friends of friends. There are so many good things that can come out of asking people to help. You might even find someone who is interested in helping you film and edit. Not only did you get to borrow a piece of equipment but you probably have made some new friends.

5. **Investigate grants**. Check out librarygrants.blogspot.com and the library grant index at www.technologygrantnews.com/grant-index-by-type/library-grants-funding.html. These resources are both good starting points to investigate possible grants.

In conclusion, although you can spend thousands of dollars on video equipment, it isn't necessary. You can now tell a story using video for just a couple of hundred dollars or less. Equipment is such a small hurdle to jump. Don't let it be an excuse not to start creating videos.

▶2

PLANNING

▶ **Get Staff Buy-In**

▶ **Create a Script and Storyboard**

▶ **Find Locations and Actors**

▶ **Plan Your Shooting Sequence**

▶ **Put Your Shots Together**

▶ **Learn the Rules of Composition**

▶ **Look for Inspiration**

▶ GET STAFF BUY-IN

New ideas will sometimes generate resistance from parts of the organization, especially during tough economic times. Take this opportunity to share with people how other public libraries are using video to promote their institution and to interact with their community. Resistance is the signal to educate and communicate your vision. You are not looking to convert or defend, but to share. It is a good time to remind people that we use posters and newsletters to promote, and video is just another medium with the possibility of reaching a far larger audience.

▶ CREATE A SCRIPT AND STORYBOARD

How to Create a Script

You have come up with a great idea, so what's the next step? Write a script. A script helps you and those working with you in a number of ways. It gives your ideas form and structure. A script will help you communicate your vision to others, and it is the first step in planning your project. It will help you to figure out how many people will need to be

involved and will help when you are looking for locations to shoot. Scripts bring your ideas into reality.

If this is your first attempt at writing scripts, then start simply. No one is expecting an Oscar Award–winning screenplay, and neither should you. A good place to start is with a monologue (see Sample Monologues). It could be about a library service, program, or author visit.

Sample Monologue: Service Announcement

Beginning: "Hi, I'm John Smith, the Readers' Services Librarian at the Allen County Public Library. Today I would like to share with you an exciting new program we are starting. . . ."

Ending: "Come down and join the fun. The staff and I look forward to serving you."

If you want your monologue to look professional, copy the professionals. They introduce themselves, telling you about their position and organization. They give you the information, and then they sign off.

After you have completed your first draft, give it to a friend or two to review. Ask your friend to read it out loud. Your goal is to have the script sound hypernatural. What I mean is that most of our regular conversations contain the er's, um's, and pauses we interject while we think about what we are saying. Have you ever sat in a movie theater or watched TV and thought, "I wish I could be as funny, quick witted, or cool as this character"? Well, it's all in the dialogue. This will mean that you need to rewrite and rewrite.

A script with just one person talking is best for presenting information. When we introduce another person we now have two focal points for the viewer to watch, and we can go from just presenting information to telling a story. A good example where this back and forth happens is the news. An anchor gives some information, then a reporter in the field tells the story, and then the anchor and reporter will engage in a back-and-forth interaction.

Write dialogue with two or more people when the goal is to tell a story. Create an opening sentence that instantly captures the viewers' attention and sets up the situation. Your characters have to be instantly recognizable, and the dialogue has to be believable. An anonymous man walking down the street is an unknown to the viewer. A man with

Sample Monologue: Service Changes

Here is a monologue I wrote to introduce our patrons to some upcoming changes at the Allen County Public Library:

Hi, I'm Sean Robinson, the IT Manager here at the Allen County Public Library. As you know, in the next couple of years the library's budget will be reduced even as we continue to see demands for our services increase.

In 2009 we will be looking for ways to automate certain processes while still offering you the same high level of service.

In February 2009 we will be reviewing three self-check machines at our downtown library circulation desk with the hope that these machines will assist you in checking out library material. We are looking for your input and an evaluation form will be available for you to fill out.

These machines will not replace any employees within our organization but will free up staff to do what they do best, which is serving you.

On April 1st we will be adding PINs (Personal Identification Numbers) to every library card. You will need to use this PIN just as you would at an ATM when you sign on to the library catalog. PINs have been an option in the past but we feel that with the addition of self-check machines, this added security is necessary.

If you have any questions about these or any other changes that are happening at the ACPL, please feel free to contact our Community Relations Department.

a wife and two children is automatically defined as a father. Inject humor, as it will help lighten the situation and associate a good feeling with the story you are telling. Alfred Hitchcock once said a good story is "life with the dull parts taken out."

Whether we like it or not, libraries and librarians have been stereotyped. This can be advantageous, however, as the character is clearly defined and can then be altered in a number of ways.

One idea that takes the old image and redefines it is to have librarians play Rock Band. Rock Band is a computer game that can be played on a Sony PlayStation, Xbox, or Wii and simulates an actual band with guitar, drums, and microphones. Issuing a battle of the bands challenge to the community as part of a program to promote computer gaming at the library takes an old stereotype and characterizes it in another way. You need to be careful with the dialogue. There is the temptation to go over the top. Don't have your characters say things that are not true to them. Your accountant would probably not refer to you as "dude," and a librarian is not likely to say "awesome." The humor is in

the situation and the fact that characters are being true to themselves (see Sample Script). For example:

Bad: "So we challenge you dudes to a Rock Band battle royal!"
Good: "So you think you can beat a librarian at Rock Band?"

Both are challenges; one is just more believable.

Sample Script: Librarian Rock Band

Formatting Intro: Librarians versus You!
Fade In: Opening scene: Four librarians in a cubicle, one with drum sticks hitting table, one with guitar, one with bass, and one with microphone, all doing warm-ups. The opening shot is of the entire group to set the scene that they are waiting backstage. There are close-up shots of drum sticks and guitarists warming up.

Manager: Are you guys ready? You go on in two minutes. *(Close-up of Manager's face while he is talking.)*
Bass: Yeah, we're ready. *(Close-up of Bass player's face while he is talking.)*
Guitarist: We've waited a long time for this. Let's give them a great show. *(Close-up of Lead Guitarist's face while she is talking.)*

(The group walks out onto the stage and sets up. Drummer counts them in.)

Drummer: One, two, three.

(Shots of them playing the song and finishing.)

Singer: So you think you can beat a librarian at Rock Band? *(Close-up of Singer's face.)*
Fade out: Closing scene, with credits explaining the program and the times and showing the Web site's URL.

How to Storyboard

Storyboarding is the process of taking your script and telling the same story in pictures. Storyboards are used to help you break your story into separate, distinct pieces and begin to plan out your shots and angles. If others are helping you film, the storyboard will show your vision, as well as the angles and elements you want to capture. The Sample Storyboard that follows is for the script presented in the previous section.

Sample Storyboard: Librarian Rock Band Script

Opening wide shot of the band (left) establishes the scene. Close-up of the Manager (right).

▶ Figure 2.1: Opening Shot of the Band

▶ Figure 2.2: Shot of the Band Manager

Close-ups of Guitarist and Drummer warming up.

▶ Figure 2.3: Close-Up Shot of Guitarist's Hand during Warm-Up

▶ Figure 2.4: Close-Up Shot of Drummer's Hands during Warm-Up

Dialogue for Bass Player and Guitarist. Each shot is a close-up on the face.

▶ Figure 2.5: Close-Up Shot of Bas Player

▶ Figure 2.6: Close-Up Shot of Guitarist

(continued)

(continued)

Wide shot of the entire band playing. Singer's dialogue. Close-up shot.

▶ Figure 2.7: Wide Shot of the Band Playing ▶ Figure 2.8: Close-Up Shot of the Singer

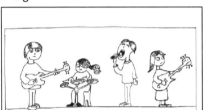

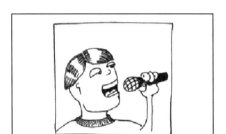

▶ FIND LOCATIONS AND ACTORS

How to Find a Good Location for Filming

Location is all about enhancing the story and adding meaning to the scene. If you are talking about technology, then you could film next to your computer center. If you are presenting information about the library, then a good location would be a book display. If you are giving a specific message, such as your closing time, then think about using the front of the library as a backdrop.

Scout your location in advance. You will need to know the light and sound levels in your chosen space. Are there any noisy air vents close by? Are you wanting to film in a high-traffic area and may need to think about filming before the library is open? See where the power outlets are located, and decide if you are going to need to bring electrical extension cords. To help me think about my camera angles, I take pictures of the location and lighting environments.

How to Find Actors

Ask your friends at work. They are the ones who will find it hardest to say no. You can also put out a general casting call. You will be amazed at how many talented people there are within your organization. Take the time and do some screen tests. Give them a little dialogue to read, and see how they come across on film. You are looking for people who are naturally relaxed, smiling, and funny.

You won't always find people who are available when you need them, so it's good to polish your own on-air skills. Unless you are a natural, you will have to practice. The more you sit in front of the camera, the easier it gets. Some tricks are to smile while talking, speak slowly and clearly, and keep your hands, arms, and body still and relaxed. If you're nervous, the audience will be nervous. Be conscious of physical and verbal twitches. Film yourself and then review. Look at things you want to improve and then repeat until you are happy with the results. It is not uncommon to need 10 to 20 takes to get it right. Be patient with yourself—acquiring these skills takes time.

▶ PLAN YOUR SHOOTING SEQUENCE

The sequence of your story and the sequencing of your filming don't need to be the same. Your goal is to shoot the video as quickly and efficiently as possible. Many times it is not possible or desirable to shoot everything on the same day. Figure 2.9 presents one way to shoot the Rock Band video scripted in the previous section. Schedule each individual who has dialogue separately, and shoot segments separately, for example:

1. Manager's, Singer's, and Guitarist's dialogue: Can all be shot separately.
2. Close-ups of Guitar, Drums, and Singer: Can all be shot separately.
3. Band group shots: Need entire cast.

The straight vertical lines that run through the script in Figure 2.9 show the actors' speaking parts, and the wavy lines show when they are silent. You can get a small handheld whiteboard and use it to mark your shot, for example: Write IB take 1 on the whiteboard before you do the close-up of the Manager's dialogue. If you need a couple takes to get it just right, no problem, just make sure to document each take on the whiteboard. A shooting sequence diagram will help you organize yourself while you are on set and is a great way to track all your shots. The last thing you want to find when you are editing is that you have missed something.

▶ Figure 2.9: Shooting Sequence Diagram

MANAGER
MED CU ECU REV

BASS
MED CU

GUITAR
MED CU

DRUMS
MED CU

SINGER
MED CU ECU

1A 1B 1C 1D 1E 1F 1G 1H 1I 1J 1K 1Ka 1L

Librarian Rock Band

Formatting Intro : Librarians vs. You!

Fade In:

Opening scene: Four librarians in a cubicle, one with drum sticks hitting table, one with guitar, one with bass and one with microphone all doing warm-ups. The opening shot is of the entire group to set the scene that they are waiting backstage. There are close up shots of drum sticks and guitarists warming up

Manager
"Are you guys ready? You go on in 2 minutes."
(Close up of managers' face while he is talking)

Bass
"Yeah, we're ready."
(Close up of Bass players face while he is talking)

Guitarist
"We've waited a long time for this. Let's give them a great show."
(Close up of Lead Guitarist face while he is talking)

The group walks out onto the stage and sets up.
Drummer counts them in

Dummer
One, two, three

Shots of them playing the song and finishing.

Singer
"So you think you can beat a librarian at Rock Band?"
(Close up of Singers face)

Fade out with credits explaining the program and the times with a link to the website

1 m WS
 MED Establishing shot of band in cube
 CU

1 n WS REV Band walking out to stage
 WS

1 o MED Band walking
 MED REV through door

1 p WS Band finishes
 CU Each band member
 MS Transition shot

Shooting Jargon

There are a number of well-known shooting angles that are commonly used, and you should be familiar with them. These are camera angles that work and that your viewers are subconsciously expecting. Camera work is a craft, and learning these shots will go a long way to improving the quality of your production. The abbreviations for the following terms appear in the shooting sequence document in Figure 2.9:

▶ **Close-up (CU)**: The face takes up most of the shot. One trick is to crop the top of the head in close-up shots to focus the view on most of the facial features and the eyes. This shot is used in TV commercials.

▶ **Extreme close-up (ECU)**: This is a tightening of the close-up shot. An example of an extreme close-up is to focus on the eyes to show fear or on a smiling mouth to show happiness.

▶ **Medium shot (MS)**: This is most often used with two people and will be waist to head. Don't crop the heads in this shot, as you want to provide a little information on their surrounding environment.

▶ **Wide shot (WS)**: This is a full body shot and is used to capture the scene. It is also called a "master shot" and is a simple way to start a sequence.

▶ PUT YOUR SHOTS TOGETHER

Some shooting sequences that go well together employ a combination of the previous shots. Here are some examples:

▶ **Reverse shot**: The reverse shot is a classic. Start with the establishing shot and then follow it with a shot in the reciprocal angle. An example is someone pointing at and looking in a direction. The camera's viewpoint would be in the direction of the character, and then the next shot is the reverse looking back at the character pointing. A two-person conversation can employ this technique to great effect. Each shot is over the shoulder of the person listening, and the camera is pointed to the person talking.

▶ **Cutaway shot**: A cutaway shot is when you show an activity and then capture another aspect of the scene. An example is when the first shot is of a person typing on a keyboard, and then the next shot is a close-up of his or her fingers on the keyboard. Cutaways help in the editing and add visual interest to the story.

▶ **Point of view (POV)**: The POV shot is where the camera becomes the eyes of the character. This is then followed with the reverse angle showing the viewer. An example is someone peering around a corner; the reverse shot then shows the person's head coming around the corner. The interesting thing here is that you are play-

ing with time; the viewers know that these two events happen at the same time, but they don't suffer any time discontinuity when viewed sequentially.

There are no hard and fast rules. Watch any TV ad, and you will see an amazing collection of sequences. Sit down with a notebook while you watch TV and write down the sequences that you enjoy, and then try to copy them. Sequences are there to help you tell your story.

▶ LEARN THE RULES OF COMPOSITION

Creating a balanced, aesthetically pleasing video image is easy with a little knowledge and a commitment to resist the urge to just pick up the camera and start shooting. The first composition guideline is the rule of thirds.

To achieve a balanced image, divide your picture frame both horizontally and vertically into thirds, and place your subject's focal points along these lines. Most of your videos will probably involve people talking. It is a common mistake to place their eyes in the center of the screen. Compositionally, it is better to place their eyes on the top third horizontal line. Be aware that visual proximity is equated to intimacy. So if you want to share information, connect with your patrons, and elicit a feeling of trust, proximity will help you achieve it (see Figure 2.10).

Another important concept in composition is the idea of headroom. Headroom is the space between the top of a subject's head and the frame. Too much headroom and it will unbalance the picture, with the

▶ Figure 2.10: Example of the Rule of Thirds in Composition Framing

subject appearing to be drifting toward the bottom of the frame. Too little headroom and it will give the impression that the subject is colliding with the ceiling and will cause the viewer to feel claustrophobic.

There are a couple of tools you can make to assist you with your compositions. Take a blank piece of plastic transparency, and cut it to the size of your camera's viewfinder. Then take a magic marker and create a grid on the transparency, and place it over the viewfinder. This will help you with your compositions. Another tool that can help train your eye is to create your own viewfinder from two L-shaped pieces of cardboard. Think of the rule of thirds as a guideline to train your eye, rather than a rule that can never be broken.

Room to move is another important concept. This is where you leave space on one side of your frame for the subject to move into. This space allows the subject to travel into that space as your camera moves. An example is someone walking from right to left. Always keep the subject in the right-hand third of the frame as he or she walks.

▶ LOOK FOR INSPIRATION

"I want to do a video, but I can't think of anything!" I carry a small notebook with me all the time and whenever I see something that I think is funny or interesting, I write it down or do a small drawing that captures that idea. Stealing other people's ideas or mashing them up and reformulating them is a time-honored tradition and is how Hollywood makes blockbusters and regurgitates them into series. I think sitting in a room and trying to be inspired is nearly impossible, and sitting in a room with a group brainstorming is a recipe to create a watered-down, mediocre idea. It is my experience that ideas come from individuals or partnerships of two. Anything larger and you enter the realm of compromise, and if you are going to put in all this effort you shouldn't start the project with a compromise. They don't make statues of committees!

Planning is a very important part of creating your videos. Planning is the cheapest way of improving your video quality. I hope this chapter showed you how to come up with ideas and ways to structure and improve your video quality. Proper planning in the beginning will ensure a smooth and successful video shoot.

Ideas for Library Videos

▶ Interview librarians about what they are reading.

▶ Interview patrons about why they love the library.

▶ Promote a program.

▶ Find and interview a local author.

▶ Teach a feature of the online catalog, for example, how to sign up for e-mail notification.

▶ Find and interview a local artist and show his or her work.

▶ Create a video log about what's happening this month at your library. Commit to do this for a year.

▶ Capture your Staff Day on video, and post it to YouTube.

▶ Interview your director about the future of the library.

▶ Capture a program that you are running.

▶ Create a video about the history of your library. When was it created, and how long has it been in the community?

▶ Create an entry for Computers in Libraries InfoTubey Awards that captures your library's services.

▶ Time capture in still motion a day at your library to show how many people come and go.

▶ Teach how to use an online database, post a comment on your library blog, download an audiobook from your collection, or sign up for a computer.

▶ Show a live video stream of a speaker, author, or event.

▶3

IMPLEMENTATION

- ▶ Make a Basic Video
- ▶ Create a Variety of Library Videos
- ▶ Add Quality Techniques
- ▶ Add Imagineering Techniques
- ▶ Create the Final Product

▶ MAKE A BASIC VIDEO

There is nothing more exciting, challenging, and ultimately reward-ing than creating a library video. Library videos offer many exciting and diverse opportunities to communicate, educate, promote, and reach out to your patrons. It is a chance to talk directly to them and share all the wonderful services and resources that you offer. In this section we will look at a number of library video projects that you can tackle. We will begin by covering the basic building blocks that you will use in every future video project. The fundamentals that I cover such as set design, lighting, and picture composition are skills that you will refine and perfect over time. This knowledge will elevate your produc-tion quality and provide a solid foundation for you to build and grow.

How to Create a Basic Video

So, what are all the things you need to do to create a basic library video? You have a great idea, and you've written the script. You've spent some time storyboarding and thinking about how the video will flow (see Chapter 2 for tips on planning). You might even have done a little scouting for locations. Now you're ready to get down to business.

Let's start by looking at set creation. This can be as simple as filming in an office or out in the stacks. Thinking about the space where you plan to film as a movie set helps you to see it with fresh eyes. You will be-

gin to plan out where your actors are going to sit, what lighting needs you'll have, and where the camera should be placed.

Create a Set

You don't need a large space to create an effective movie set. Here I will use my home office as an example. I often find myself filming in small cubicles or offices. This is where a portable lighting kit and free-standing lamps come in handy. You can use these to supplement the lighting already in the room. I use energy-saving fluorescent bulbs because they have the same color value but draw less power than traditional bulbs. (I'm not talking about the fluorescent tubes used in buildings that cast a greenish glow.) You don't want to accidentally blow a breaker. The only major rule is not to put the light source directly behind the actor. It is preferable for it to come from a front angle (see Figure 3.1).

Getting a good image and sound is all about controlling the environment. In the home office example I have set up the lighting, and the camera is securely mounted on a tripod ready to shoot. The door is closed and the computers are off. Be aware of anything else that could

▶ Figure 3.1: Creating a Set in a Small Space

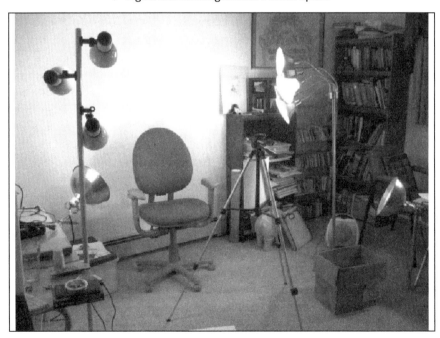

make an ambient sound. If you are filming in a shared space, do the best you can. If all else fails, try yelling "All quiet on the set!" You never know, it might work.

Prepare Your Location and Control Your Environment

The devil is in the details. Remember, things always take longer to set up than you would think, and things that worked yesterday will fail right when you need them the most. I have learned this from experience.

Allow yourself lots of time to set up. You want to have everything ready so you can start filming as soon as your actors arrive. Schedule them to arrive about an hour to an hour and a half after when you plan to arrive. This will give you time to preset your lighting, camera, and sound, and keep the talent from standing around.

You are going to need some assistance, so ask a coworker to act as a stand-in to help you get your lighting and sound levels correct. Of the three types of microphones discussed in Chapter 1, the shotgun and the lavalier will both work in the small location, but the shotgun is nice because you don't have to fiddle with someone's clothing. Having said this, I seem always to fall back and use a lavalier because it does a better job cutting out ambient noise.

You can create great videos with the simplest equipment. Just remember to control your environment and give yourself plenty of time to get your lighting and camera angles correct.

You should have a good idea ahead of time how you want to light the set. The standard lighting configurations, described in the quality control section of this chapter, will work. Set up the tripod, and attach the camera. Set the tripod to the correct height, and set the camera at the approximate angle. Don't worry about getting it perfect. You will be fine-tuning later.

Plan Costuming and Appearance

You want your actors to look good, and here are some clothing guidelines to follow and suggest to people whom you plan to film.

Dark-colored clothing is generally a better choice than light-colored if the actor has light facial features. This choice can be altered depending on skin tone. Blue shirts are preferred over white because a white shirt will give your camera an unneeded contrast challenge. Stay away from floral prints or patterns, as they don't film well. Consider using beige, reds, browns, blues, and black as a color palette and going with a classic clothing style.

If the actor is sitting and wearing a jacket, have the actor sit on the back of the jacket. This will prevent it from bunching and give a clean profile.

Bring a comb and a small mirror to the shoot. It is your job to make sure that your actors look neat. Keep a couple of hair ties on hand; tied-back hair looks good on camera.

Also, have a little concealer and powder on hand. Men might not want to wear makeup; you, on the other hand, don't want to film a guy who looks like a shiny, sweaty mess. So use your people skills and negotiate the issue. Talk to your actors the day before about clothing and makeup. Give them suggestions or just ask them to wear certain clothing and colors. This way you won't be surprised on the day of shooting by your actor showing up in a Hawaiian shirt.

Most spokespersons don't wear glasses while on camera, so, unless glasses are an integral part of the actor's personal identity, try filming without them. Glasses can be a barrier to connecting to an audience because they reflect images and hide the eyes.

Review Your Shooting Sequence

Before you start filming, review your shooting sequence (see Chapter 2, "Plan Your Shooting Sequence," if you have not yet created one). You should have your shooting sequence documented ahead of time so you can check off each section after it has been filmed. Sometimes the shooting sequence is going to be very simple, but get into the habit now of writing them out and following them. There are a lot of things that will happen simultaneously on a shoot, so the more you plan and document, the easier the production will flow.

Check Equipment and Audio/Lighting Levels

In preparation for every video that I shoot, I create a checklist of things that I need to do and things that I need to have. A checklist will save you from keeping everything in your head.

Check your equipment. Make sure that your batteries are charged and that you have enough space available either in your memory stick or on tape to capture more than enough footage. Make sure that you bring everything to the shoot that you will need. Here is my list:

1. Tripod
2. Camera
3. Lighting equipment
4. Script

5. Makeup, comb, tissues, and mirror
6. Spare batteries and bulbs
7. Spare video tapes and/or memory stick
8. Microphone
9. Power cords
10. Extension cords
11. Water for the actors

Check audio levels. The stand-in should have arrived by now and can help with setup if you have fallen behind. Attach or place the microphone, and record the stand-in. Play the recording back, listening to determine that audio levels are correct and that the microphone isn't picking up any unwanted ambient noise, such as computer fans.

Check lighting levels and composition. Start doing some fine-tuning on the lighting levels with your stand-in. Place the stand-in where your actor will begin, and go back to the camera and review the composition again. Look for things that might distract from the actor, such as a poster in the background or anything else that will draw the viewer's eye away from the actor. Now capture some test footage while the stand-in talks. Make sure you are capturing the footage at the right ratio and rate, and at the highest quality possible. Play it back and make sure that you get what you were expecting.

Practice Before You Film

There is nothing wrong with spending a little time running through some mock setups. Your actors will thank you if they can just walk in, be filmed, and walk away without having to sit there for 30 minutes watching while you fiddle with equipment.

Prepare Your Actors

When your actors arrive, the first thing to do is thank them for coming and make them feel relaxed. Answer their questions, and make sure that they know the script. You might be stressed, but don't stress out the talent. Give them some water. While they are opening the water you are going to be looking at their clothing and making sure that everything looks okay.

Add a little makeup by putting the tissue around their neck and adding a little face powder to their face. This stops any glare and will make them look better on camera. Check their hair and offer a mirror

or comb if needed. If they are hair-impaired, a little powder will reduce the "chrome dome" effect.

Fine-Tune and Film

Check the lighting, camera, and picture composition. Attach the microphone and check audio levels one more time. Ask the talent to talk a little and capture your final piece of text footage. After everything is filmed and you say, "It's a wrap," be sure to thank your actors and your stand-in. Eject the memory stick or tape and label and date it. Put it away so you don't lose it or pick it up and overwrite all your hard work.

You are going to repeat these steps on every production. The first set you create will take more time than you think to set up. You will get faster as you gain experience, but the first couple of times can feel overwhelming. Don't worry, you will become an old hand at this quickly and it gets easier the more familiar you are with your equipment.

Quick Checklist: Create a Basic Video

❏ Create a set
❏ Prepare your location and control your environment
❏ Plan costuming and appearance
❏ Review your shooting sequence
❏ Check equipment and audio/lighting levels
❏ Practice before you film
❏ Prepare your actors
❏ Fine-tune and film

▶ CREATE A VARIETY OF LIBRARY VIDEOS

How to Create a Library Marketing Short

What is a marketing short? A marketing short is nothing more than an ad for your library. The challenge that faces everyone who wants to be heard in the online video world is to create an ad that viewers will watch multiple times and share with their friends. The ultimate goal is to make the message go viral. To do this you have to have a great concept, a strong message, emotion, and energy.

Script Your Message

Why create a marketing short? Libraries need to compete just like everyone else to get the public's attention. Gone are the days when we

can passively offer outstanding services. We need to constantly tell people what a vital role we play in the community. We need to share our story and promote our library services in new and engaging ways. One strategy I use is to study advertisements that I love and analyze the elements that make them successful. Marketing shorts should run between 30 and 60 seconds. You can create a powerful message with the right images and words.

Marketing shorts can be time sensitive, for example, announcing an author visit or a library event. If your short is promotional, plan to release it about six to eight weeks ahead. I have found that on average our patrons view our Web site once every 30 days. We promote by embedding the video on our homepage, and a six- to eight-week promotion period gives us the best results. Sit down at the beginning of the year and lay out a calendar of events that you know are coming. Then plan backward, making sure that you have enough time to film and edit.

Capitalize on existing buzz and create media tie-ins to draw attention to your message. Your tag line could go like this: "Everyone is excited about the upcoming movie, but did you know that the story was based on a book?" Show the book and give a little information about the author.

The undercurrent to any marketing short is its hook. The hook is what makes people watch videos again and again. Juxtaposition, repetition, playing against stereotypes, and the absurd are some tools you can use to create a concept for the hook. Your message will then ride on the concept.

Some ideas would be zombies chasing patrons into a library (I actually used this one, but more on that later) or the *Texas Chainsaw Massacre* character coming to the library to get a Do-It-Yourself chainsaw repair book. The concepts are bizarre, but the message is the same: Libraries are here to help no matter who you are.

Use Images

The words in the script can convey the message, but not as well as images. Think of it in terms of branding and then associating emotions to that brand. Soft drink companies are a great example. Some associate their product with summer and fun, others with danger and risk, and still others with energy and vigor.

Say you want to create a summer reading program video. Ask yourself, "What is the message we want to send out with our Summer Read-

ing Programs?" Many summer programs offer prizes for registering for the program or for reading a certain number of books. You can make it a challenge: "How many books can you read this summer?" Here the message has changed from just trying to promote a reading program to a competition. The end result is still the promotion of reading. Every library has its own approach. Take time to create a clear and simple message.

Using the summer reading program as an example, what are the images you would want to capture in a 30-second ad to convey your message? For an example, see the Sample Marketing Short.

Sample Marketing Short: Summer Reading Program

Image 1: Waiting for the Program to Start
Show kids looking for the information in a number of ways: searching your Web site; reading your newsletter; waiting by the mailbox, if you send out a flyer; marking off the calendar day by day; watching a clock as it slowly ticks. Convey the feeling that people have been waiting for this program to start.

Image 2: Rushing to Register
Show people registering for the program, both online and at the registration desk. Convey two ideas: everyone in the known world is registering, and you better rush and register right now. This can be done by rapid edit of person after person registering. You can also play with time and speed up the footage.

Image 3: Creating an Urgency to Read
Show people searching for books and taking them in large piles to the checkout desk. The idea to convey is, "Get your books while you can. They are going fast, and you don't want to miss out." You don't want to create a feeling of fear, rather a feeling of urgency—a fine balance.

Image 4: Reading
Show people reading. Show them reading at breakfast, lunch, dinner, in a tree, on a park bench, in the car. Convey the message that in the summertime everyone is reading, everywhere.

Image 5: Returning Material and Finishing the Program
Show people returning books, getting prizes, and then taking out more books. Convey the message that even though the program is finished, people continue reading.

See how much information you can squeeze into 30 seconds. It's a challenge!

Edit for Effect

One way to create excitement is through editing. On a 30-second piece of footage try increasing the number of edits to add pace and excitement. As an exercise, count the number of edits on an average

30-second television commercial. You might be surprised. The people who create these commercials are masters of editing and imagery. Try to copy and replicate their techniques.

One of the most successful marketing shorts created for our library was "Reference Zombies." I collaborated with Kay Gregg to create this film. The story is of a young couple being chased through the streets by a band of zombies. The couple run into the library and find the book *The Zombie Survival Guide*. This book and the public library will help them survive the perils of the undead. It is fun, lighthearted, and helps redefine the image of our public library (see Figure 3.2).

Here are three basic editing techniques that I used when creating this video. The first is at the beginning. The video starts with an establishing shot. This is designed to give the viewer lots of information. It shows that it is night, the streets are deserted, and we are somewhere in the Midwest. The next edit shows our young couple. The purpose of this edit is to introduce the two main characters and draw the viewer into the story. The edit combination of establishing shot to character shot is one you will use repeatedly. The next edit combination is the reaction edit. Here you take the close-up shot of the characters reacting

▶ Figure 3.2: Zombies Converging on Two Victims

to something. In this case the young couple has just seen their first zombie. The next edit is to what they have seen, the zombie, and then we edit back to their reaction. These can be quick edits to show that the couple's emotional state has changed. The final example is the point-of-view edit. It is filmed from the point of view of the zombie chasing the couple and then cuts to the close-up of terror on the couple's faces as they try to escape. Point-of-view edits are fun and give the viewer an interesting perspective.

Another great marketing video was created by our genealogy department for a military symposium event it was conducting. Department staff worked with a local Civil War reenactment group and filmed soldiers running through the stacks. It was high energy and creative. It involved the community and literally brought history to life (see Figure 3.3).

This video, "Genealogy Center's Military Symposium Part 1," shows another nice way to introduce an opening establishing shot. The edit is done by superimposing one image over the other. The first shot is of the entrance to the Genealogy Department and the second shot is of

▶ Figure 3.3: Civil War Soldier Charging through Library Stacks

the reference desk just inside the department. Here the edit is done as we transition from one shot to the other; notice that the second shot pans from left to right. Superimposing images can be used if you want to provide written information in your video footage. Here it is done at the end of this video to inform the viewer of the name of the program, the date, and contact information. This technique creates smooth clean transitions.

Remember that marketing is all about concept, message, planning, and images.

Quick Checklist: Create a Successful Library Marketing Video

❑ Script your message
❑ Use images
❑ Edit for effect

How to Create a Library Service Instructional Video

Libraries are changing rapidly, and we are using new ways to manage and automate services. How can we inform and educate our patrons and staff? The challenge is to teach, show, and share these new processes—anything from an automated PC reservation system that requires a library card to register to a new parking validation system. A well-thought-out library service instructional video can help both staff and patrons. It is a great way to communicate and distribute the information, with the advantage of saving staff time by not having to constantly answer the same questions.

Know Your Audience

Your audience is your staff and patrons. It is important that the information you present be clear and simple. Don't confuse or overwhelm your audience with too much detail. Talk about and demonstrate the process. A good model to emulate is a cooking show. They talk while demonstrating and keep the tone fun, friendly, and informative.

Write a Script That Informs/Teaches

We introduced our new pay-for-print service through an instructional video. Pay-for-print allows patrons to use their library card as a debit card to pay for pages they print.

The easiest way to write the script is to imagine yourself as the patron and that this is the first time you are learning about the product. In this example, we took viewers step by step through the process of adding value to their library card. We started by showing them the location of the add value kiosk, and then we demonstrated how to swipe the card and add value (see Figure 3.4).

Because this technology is new to everyone at the library, we wanted staff to be comfortable answering patron questions, so the dialogue had a subtext of staff education. Our goal was to answer all potential staff and patron questions. We hoped this would empower patrons to act independently and relieve staff from repeatedly having to answer the same questions. We had an audio track but we also subtitled the script for the hearing impaired and created two videos, one in English and the other in Spanish (see Figure 3.5).

Use Cue Cards

We could not expect actors to remember the large amount of dialogue, so we wrote the script on cue cards. Place the cue cards under the camera so that the actor can look into the lens and talk directly to the audience (see Figure 3.6). If you are going to be bilingual, don't

▶ Figure 3.4: Janet Demonstrating New Pay-for-Print Kiosk

Pay For Print Instructions, Creating an Account.

The first step is to set up your account.

0:22 / 1:54

watch in high quality

▶ Figure 3.5: Maria Demonstrating New Pay-for-Print Kiosk in Spanish

▶ Figure 3.6: Placement of Cue Cards

expect your actor to be able to translate on the fly. Create a separate set of cue cards.

Quick Tip

Begin and end your shots with the actors looking into the lens. This prevents them from breaking their connection with the audience. After they say their last line, they should again look directly into the camera and smile.

We have had nothing but positive feedback with our service instructional videos. They have been extremely helpful when implementing a new service, and I recommend you use them too when offering something new.

Quick Checklist: Create a Service Announcement Video
- ❑ Know your audience
- ❑ Write a script that informs/teaches
- ❑ Use cue cards

How to Create a Library Video Tour

Library video tours aren't just about the facility and its features. It's about inviting your patrons to come and visit and showing them the warm welcome and the friendly service they will receive when they do. It's also about the pride you feel being part of the community. It's much more than just a video tour.

This section describes the basic elements you need to create your own video tour. How long should a library tour video be? Keep it to three to five minutes. You don't need to film everything. Allow the patrons the opportunity to discover and explore the library on their own. And, anything longer than five minutes and you risk becoming boring. This might be the first impression that someone has of your library, so make it a good one!

When filming, follow the basic library video model of setting up your tripod and camera and pointing at your actor. If you want to include a little dynamic footage, use your tripod as a steadicam (as explained in the quality techniques section of this chapter). This technique allows you a little more flexibility with shots, and you can show your actor entering various departments. This type of visual in-

formation will help your visitors orientate themselves in the building better than just fixed footage from a fixed angle.

Depending on the size of your library system, this could be as simple as a single-day shoot or end up being a multiday endeavor. Either way, begin with the basic building blocks. The secret is to pretend that you have never been to the library and are discovering it for the very first time.

Introduce Your Library

The tour begins from the patrons' point of view at the moment they enter the library. So the first thing you do is welcome them, introduce yourself, tell them the hours you are open, and remind them to bring a couple of things, such as identification to obtain a library card. If they need money for parking, let them know, including how much the parking lots or meters cost. Show and tell them where all the parking lots are. For those not traveling by car, provide information about bus routes and bike racks. Then tell them how to get to your location. People who are not familiar with your downtown can find it confusing. If they are watching the video, they are probably not regular visitors or may be new to the community, so all this information is helpful.

> **Dialogue**: We have a couple of parking options available. Wayne Street provides access to our underground parking, and we have two surface lots, one on Washington Boulevard and the other off Wayne. Parking costs $1.00 per hour, with a maximum daily charge of $7.00. Metered street parking is also available. Parking is free if you have a valid Allen County Public Library card. The closest handicapped parking spots are located on the east side of the building in the Wayne Street lot.

> **Camera shots**: We can use four shots to convey our parking information. The first is in front of the garage, then one each of the two surface lots, and then one in front of a parking meter.

Film as early in the day as you can so that the sun is not overhead. Plan your production for the nicest time of the year. Filming a library tour in the dead of winter is not a good idea, but spring and early summer are just beautiful.

If you have more than one entrance, show them all. Also show where the restrooms are located. Visitors who have traveled a while might find this their first priority, so show the restrooms that are closest to the entrances.

Describe Your Services

Those who are new to the library will want a library card. Once they are in the building, this is the next logical thing to show them.

> The circulation desk is where you sign up for a library card. You need to bring in some form of identification. Call [phone number] if you have questions. The circulation desk is located in the middle of the first floor in the great hall. Library cards are free for all Allen County residents.

Where will your patrons go next? Is it to the Art, Music and Audio Visual Department to check out a DVD or to Readers' Services in the fiction section? Does your library have a unique collection, such as genealogy or local history? Highlight some of your most used departments.

> If you are interested in a good book, then Readers' Services is the department you'll want to visit next. We have a great selection of mystery, romance, and science fiction. If you have trouble finding what you want, just ask a librarian. We are here to help.

Storytime for kids is another extremely popular service. At some libraries, it could be computer classes. The tour is not only about the building but also about your popular services. Capture some footage of one in action.

> Storytime is presented twice a week in our orientation room. This program promotes early childhood literacy. The orientation room is located next to the Children's Department on the first floor on the west side of the building next to the big globe.

Each library has its own way of organizing its collections, and this is not always intuitive to newcomers. For example, at the Allen County Public Library, we divide our graphic novels among three departments: Children's, Readers' Services, and Young Adults. This can be confusing for patrons. Think of idiosyncrasies that your library might have and explain them. Also, many communities' demographics are changing, and English might not be some of your patrons' first language. Point out these special collections.

> We have a large selection of books in many foreign languages. Our foreign language fiction is located in Readers' Services.

Provide Contact Information

At the end, thank the viewers for taking the tour with you. Tell them that you are here to serve them, and give them a contact phone number and e-mail address to use if they have questions before they come.

> So, you've watched the video and seen a glimpse of the library. Come on down and experience all we have to offer. Call us at [phone number] or e-mail us at [e-mail address] anytime you have a question. You are always welcome at the Allen County Public Library.

Remember Your Audience

Depending on your population, you may need to dub or subtitle the video in another language. This is easier than filming the entire tour twice. You can also provide subtitles for the hearing impaired or for those who might not have sound available on their PC. Understand your audience. We have a large, new population of Spanish-speaking patrons and are now producing these types of videos in both English and Spanish. Until you have been in a foreign country it is difficult to comprehend how hard it is to function in a society where you don't speak the language. Embrace these new patrons and they will be loyal customers of your organization.

You can't cover all the features of your library in five minutes, but you can create more specific videos later. For the main tour, pick the information that will be most relevant to your patrons.

Quick Checklist: Create a Successful Library Tour Video

❑ Introduce your library
 ▶ Location
 ▶ Parking
 ▶ Entrances
 ▶ Restrooms
❑ Describe your services
 ▶ Circulation/library cards
 ▶ Unique departments (e.g., genealogy)
 ▶ Programs (e.g., storytimes)
 ▶ Collections
❑ Provide contact information
❑ Remember your audience

How to Create a Library Blog Video

A video for your library blog should be between two and four minutes. They are vignettes of information. The universal rule is to welcome the viewer and introduce yourself. The goal is to make a personal connection. We use these videos to tell our customers what is happening at our libraries in the upcoming week.

We have branded our blog video as "What's happening this week." "What's happening this week" highlights events that are occurring at the library in the upcoming week. It is extremely popular, with as many as 300 views a week, and its popularity appears to be growing. The videos are designed to draw attention to the programs and activities that we offer.

We have embedded it directly into our homepage so that it is the first thing that our audience sees (see Figure 3.7). Other topics that lend themselves to the video blog approach are weekly book reviews, recently added items, this week's storytime topic, gallery displays, new movies, and upcoming programs, such as Tax Returns or Senior Week. We also use our weekly video blogs to introduce different aspects of the library by shooting at a different location each week and highlighting the staff there.

Video blogs are where you can let your hair down and not worry about production as much. A simple Webcam and a couple of rough edits and you have a journal entry.

▶ Figure 3.7: Melissa's Video Blog Embedded into the Homepage

Collect Content for the Upcoming Week

More is happening at your library than you can possibly cover in four minutes. Go through your Events Calendar and pick what you think are the most compelling activities. We like to include national library events such as Teen Tech Week and National Library Week. We have worked with the city to promote a program that the city was presenting at the library. The first ever Bicycle Summit encouraged citizens to meet with city officials to help design future bicycle paths. As a result we were able to interview the mayor. Each library has a different set of programs. You might also highlight a different set of programs each week.

Pick a Location to Film

We make a point of shooting at a different library location each week. It keeps the look of the footage fresh and exciting. The goal over time is to give viewers a larger sense of the organization.

Create a Script

Include the following basic elements in your script:

1. Introduce yourself and tell where you are from: "Hi. I'm Jane Kiser, IT Librarian with the Allen County Public Library."
2. Tell where you are and the date: "This week I am at our Main Library plaza in downtown Fort Wayne. This is the 'What's Happening' video for the week of May the 5th 2009."
3. Capture a feeling of excitement and anticipation: "We have this really cool program this week . . ."; "I am really excited to see the return of this program . . . "; "If you like book reviews, then join the book club on . . ." Make every statement positive and affirming.

Use Body Language

The actors must be relaxed and smiling in this type of video. Awkwardness and body tension conflict with the message, so the body language and script must be in sync. Figures 3.8 and 3.9 provide two examples of body language that is relaxed and happy.

Highlight a Librarian or Department

There are so many unsung heroes in our libraries. From time to time, give some pats on the back to your coworkers.

▶ Figure 3.8: Melissa Relaxed and Smiling while Delivering Her Lines

▶ Figure 3.9: Melissa Relaxed and Smiling while Standing Outside the Library

Hey, did you ever wonder how all these books get back on the shelves? It is thanks to our material support staff. They shelved X number of books last year. They work hard for you.

How does a regular book become a library book? It is thanks to the staff in Technical Services. They processed X number of new books last year. Great job!

Are you looking to do a little business research? Then the librarians in Business and Technology are here to help.

These declarations not only promote the staff but they also inform and educate the public on what it takes to make a library run. Not a bad piece of information for them to have, as library budgets are always under review.

Quick Checklist: Create a Library Blog Video

- ❑ Collect content for the upcoming week
- ❑ Pick a location to film
- ❑ Create a script
- ❑ Use body language
- ❑ Highlight a librarian or department

How to Create an Instructional Screencast

Screencasting is a great educational tool for librarians. It is designed for patrons to learn about a procedure by watching and then mimicking the actions that are being demonstrated. Patrons are both shown and told exactly what is happening on the screen, step by step. Patrons can stop, start, rewind, and work through the instructions at their own pace rather than at the pace set by an instructor in a normal classroom

setting. No longer does a librarian have to go over instructions repeatedly.

Providing computer instruction is complex and procedural. One step follows another. Screencasting is the perfect tool because it captures procedural steps in great detail, and including the librarian's voice as a guide makes the experience much like one-on-one instruction. It allows for movement, so the viewer can see how the librarian interacts with the application.

Screencasts require your patrons to dedicate a concentrated piece of time, so keep them to five minutes or less. If the subject matter is too large to cover in this time period, then break it into two separate videos.

Choose a Subject and Write a Script

If you have something to share, teach, or present, then you can screencast. We have used screencasting for everything from showing patrons how to create a Gmail account to instructing staff on how to add book recommendations to Librarything.com. In your script, tell what you plan to talk about, then talk about the subject, and end with a review of what you have said.

Assemble Your Equipment

You need a computer and software program. There are some great software packages out there that can help you get started. On Windows you can use Camtasia, CamStudio, and Adobe Captivate. On the Mac you can use Snapz Pro, iShowU, and Screenflow.

Plan Your Production Process

Hopefully you will make many instructional videos. You'll become a pro at it in no time, especially if you approach it the same way each time. Consider adopting the steps I take to create a screencast:

1. **Decide content**: Decide what to present. It can be something as simple as logging into the catalog and becoming familiar with some Online Public Access Catalog (OPAC) features.
2. **Plan**: Be thorough. Don't leave out any steps. I know this seems obvious, but if you are familiar with a process it is really easy to do. Write a script, and do a couple of trial runs following your own instructions. Also, ask someone who is not familiar with the process

to follow your instructions. This will catch anything that you might have overlooked.

3. **Record**: Go at a slow but steady pace. After a major point has been made, leave a little pause. This helps patrons absorb the information.

4. **Edit**: After all your information has been captured, go in and fine-tune. Add the title, introduction, and ending credits. If the screencast is composed of a number of distinct segments, you will need to add transitions. Each transition needs to have its own title.

5. **Publish**: You have lots of options. The screencast can be embedded in a Web page or blog. It can be added to a collection of screencasts you have created or uploaded to a video hosting service such as YouTube.

Navigating the library's physical and virtual spaces can be a challenge for some patrons. If you focus on providing a positive instructional customer experience you will always be successful.

Quick Checklist: Create an Instructional Screencast

- ❑ Choose a subject and write a script
- ❑ Assemble your equipment
- ❑ Streamline your production process
 - ▶ Decide content
 - ▶ Plan
 - ▶ Record
 - ▶ Edit
 - ▶ Publish

How to Interview a Library Director

Our future is in the hands of our library leaders. Library directors more than any other staff person take on this role and responsibility. They set the tone and tenor for your library; it is their vision, ideals, and ideas that propel us forward. Capturing their thoughts and sharing them with the staff and community helps create transparency and removes bureaucratic barriers. Library directors are just faceless names to many people. This is a chance to show them as individuals. They can talk about the upcoming challenges and the future direction of the library and even acknowledge and thank the staff. Patrons and staff will love to hear your director's thoughts and perspective.

Meet with Your Director

Meet with your director to find out what he or she wants to talk about. Library directors are generally focused on one of the four broad areas of any library: Buildings, Bodies, Books, or Bytes. The buildings involve the costs and decisions involving infrastructure. Bodies consist of staff and future staffing needs that the organization might face. Books are about collection development, and Bytes cover technology. If you steer the conversation in these areas you will get a good idea what your director is thinking about and focused on. Directors are busy people, so don't waste their time. This pre-interview should last no more than 30 minutes.

Create a Set of Interview Questions

Always start an interview with a positive affirming question. It will set the tone for the entire interview. Here are some sample questions that you can use during the course of your interview:

- How many books did the library circulate last year?
- Where are you seeing the most growth in the library these days?
- How has the library changed over the past ten years?
- What is the role of a public library in society today?
- How does the library support local schools and education?
- How does the library help small businesses in the community?
- How do hard economic times affect a public library?
- How do you manage when you find the library budget shrinking?
- Why did you become a librarian?
- Why are public libraries important?
- Do you think providing free Internet access to patrons is important?
- How has the Internet changed public libraries?
- Do you have a vision of where libraries will be in five to ten years?
- How does a library pick the material it will purchase?
- How do libraries remain relevant?
- What makes a good librarian?

Share Your Questions and Get Feedback

After you have compiled your questions, share them with the director. If you listened closely during the pre-interview, then the feedback should be positive. Don't get yourself in the situation of asking a question he or she does not want to answer. Once the questions are approved, set a time to do the interview.

Pick a Location

The location can be determined during the pre-interview by asking the director where he or she would like to be filmed. Possible locations are the director's office, his or her favorite spot in the library, or even outside.

Plan the Shooting Sequence

Focus on capturing the answers. You will need two people—the interviewer and the camera person.

Once everything is set up, give an introduction. Talk directly into the camera during the introduction (see Figure 3.10). Then turn and talk to the director (Figure 3.11), and then have the camera turn to the director (Figure 3.12). Now you're off and running with the interview.

Get Approval

Once the editing is complete, get your director's approval before posting the video. Editing can change the emphasis of the message. Make sure that your director is happy with the result.

Capturing your director's thoughts and feelings is a powerful thing to do and if done correctly can have an inspiring effect on your organization and community.

Quick Checklist: Interview a Library Director

❏ Meet with the director
❏ Create a set of interview questions
❏ Share your questions and get feedback
❏ Pick a location
❏ Plan your shooting sequence
❏ Get approval

How to Interview an Author

Have you ever thought that without authors we wouldn't have libraries? I think authors are the rock stars of the library world. They are the ones who produce the products that we offer our patrons. Authors can be mythical creatures in our imagination because they create works that defy and enthrall us. They are compelling and intriguing. Getting to know the authors, seeing them as real people, and hearing how they wrestle with the creative process is fascinating. What could be more exciting than getting the chance to interview an author and then preserving and sharing that experience with your patrons?

Sample Interview with a Library Director

▶ Figure 3.10: Talking to the Audience and Facing the Camera Directly

Introduction: Hi. I'm Sean Robinson, and today I have the pleasure of interviewing our library director, Jeff Krull.

▶ Figure 3.11: Quarter Turn to Talk to the Director

Greeting:
Hi, Jeff. Thanks for taking the time out of your schedule to do this interview.

▶ Figure 3.12: Opening Shot of Director Jeff Krull, Turned at a Three-Quarter Angle to Expose His Facial Features while Appearing to Talk Directly to the Camera

Director's reply:
You're welcome, Sean.

Ending:
I want to thank you again, for taking the time to talk to us about the Allen County Public Library and how we are moving forward and adapting to our patrons' ever-changing needs.

Do Your Research

You are probably not going to have much time to meet with the author before the interview. That is why research is so important. Start gathering background information as soon as you find out that you are doing the interview.

Where are they from? Where did they go to school? Did their parents write? Where do they live now? Are they married and do they have children? All this background information is vital because you don't want to ask a personal question for which you don't know or at least have a feel for the answer. Use the Internet. Many authors have a Facebook or MySpace page. Google their names and locate their Web sites. If they have a blog, become familiar with its content.

Know and have read what they have written, or you will be courting disaster. If you have read only a couple of chapters of their book, be honest about it and tell them. If it's fiction, know the characters and plotlines. If it's nonfiction, you don't have to be an expert but you do have to know enough to ask intelligent questions. Take a copy of the author's latest published book to the interview. If you have done your research, the questions should write themselves.

Begin with an Introduction and Welcome

> I'm Bob Corey, a Readers' Services librarian at the Allen County Public Library, and today it is my pleasure to interview renowned author Paula Gregg, whose latest work is [insert title]. Welcome to the Allen County Public Library.

During the introduction, hold up the author's latest book. Point the cover toward the camera. It's a nice way to promote the author's work.

Ask Questions

The more you can get the authors talking about themselves and their work, the more material you will be able to edit later. Here are some sample background questions:

▶ When you were growing up in [insert city], did you always want to become a writer?
▶ How do you construct your stories? Do you plan everything out at the beginning, or do they just evolve naturally as you write?
▶ What is your writing process?
▶ Do you write every day?

▶ How much research do you do when writing a book such as [insert title]?

▶ What was the biggest challenge with this book?

Then transition to questions about the current work, for example:

▶ In your latest book you have some very interesting characters. Do these characters come from your imagination or more from experience?

Of course if this is a vampire book, that last question may not be appropriate. Adjust your questions based on the material. If it's fiction, ask about plot and character development. Ask about what inspired the author to write the book. If the story takes place in a different time period, ask how the author researched that era. If the book is nonfiction, then focus on the research process, what fascinated them about this topic, and what new details the author has discovered.

Finally, you'll want to move on to questions about future projects, such as:

▶ So, what's next?

▶ After you have finished one book, is it hard to get inspired to sit down and start writing again?

Say Thank You and Wrap It Up

It has been a pleasure to have you here today to talk about your latest work [insert title]. I found this to be an insightful and fascinating book, and I personally recommend it.

The interview should be no longer than five minutes, and the final shot should be of the book.

I have had the chance to interview Stephen Abrams, Michael Stephens, and David Lee King while they were visiting our library. This is part of a series I created called "Conversations." Each of these videos focuses on what the speaker had to say. In Figures 3.13, 3.14, and 3.15, you can see that we removed all background visual distractions.

Quick Checklist: Interview an Author

❑ Do your research
❑ Begin with an introduction and welcome
❑ Ask background, current, and future questions
❑ Say thank you and wrap it up

▶ Figure 3.13: Head Shot of Stephen Abrams

▶ Figure 3.14: Head and Upper Body Shot of Michael Stephens

▶ Figure 3.15: High-Contrast Head Shot of David Lee King

How to Create a Library Services Tour Video

Libraries offer an amazing range of services and programs. The challenge is getting the word out to our patrons. How can we tailor the message to focus on a specific group? How can we give a service a new and contemporary image? How do we redefine, reinvent, and invigorate programs that may have run for decades? One way is to capture the images and energy that surround them. Video is a perfect tool to show people on the outside what is going on in the inside of our buildings.

For this discussion, I focus on four different aspects of a library: children's services, young adults, adults, and facilities. If you create a number of service videos, you may want to order them by patron profile rather than department. You are welcome to use or modify the example scripts I provide. They are designed to get you thinking and guide you when writing your own.

Highlight the Children's Department

Sample Script: Children's Department

Welcome to the Children's Department. We offer many exciting programs here during the week. On Tuesdays and Thursdays, from 10 to 10:45 a.m., we offer a storytime for kids between 0 and 2 years. This is followed by another storytime geared for kids 2–4 years. The storytimes are held in our orientation room next to the globe. All programs are free, and you are not required to register. On Wednesday afternoons, from 3 to 4 p.m., we have art appreciation classes. This is where we learn about art and create our own. This is held in the children's meeting room at the back of the Children's Department. Our early literacy room is open all day, every day, and you can drop in anytime. If you are a teacher, we will work with you to help create and design any sort of custom collection that you want to use in the classroom. Just give us a call at [phone number] or e-mail us at [e-mail address] to schedule a time to meet. Everyone is always welcome.

Filming a service segment is very much like filming the library tour. You are going to be showing the activities, where they are located, and the layout of the department. Rather than use the standard tripod interview setup, have the camera following a person as he or she walks through the department. Shoot some of the footage from a kid's level rather than have everything at adult height. This adds interest and sends the signal that this department is focused on kids. Edit in footage of each program in action.

Feature the Young Adults Department

For the Young Adults Department, use less formal language. The teens themselves will be viewing this, and you want it to be as friendly and inviting as possible.

The segment can be filmed the same as for the Children's Department, but this time add footage showing teens doing the activities. Give them an Artist Release Form (see Figure 3.16), and they will feel like rock stars. The form is not a legal document, but you should require people you film, or their guardians, to sign it.

▶ Figure 3.16: Artist Release Form Template

ARTIST RELEASE FORM

I am over the age of 18 years. _____ (*Initial here*)
I am a parent or guardian of a child under the age of 18 years. _____ (*Initial here*)

I assign and grant to the _____ (*library name*) the right and permission to use and publish electronic representations or digital creations made of me and/or my minor child on this date by the _____ (*library name*). I hereby release _____ (*library name*), its trustees, officers, employee and agents from any and all liability, losses, damages, costs and expenses, including attorney fees, which may be incurred by me or which may arise by reason of the creation of the product or as a result of the use and publication of the product.

I authorize the reproduction, broadcast and distribution of this product without limitation by and at the discretion of the _____ (*library name*). I waive the right to any compensation I may have for any of the foregoing.

Name: _____
Address: _____
City, State, ZIP: _____
Home Phone: _____
Cell Phone: _____
E-mail: _____

Date: _____
Signed: _____
Witness: _____

Sample Script: Young Adults Department

Hi. Come on in and check out the Young Adults Department. Each weekday we offer Homework Help. Teachers from the community and volunteers are available from 4 to 6 p.m. to answer your questions and help you with your homework. Every Friday between 3 and 7 p.m. we have our weekly Rock Band competition. It's always a lot of fun. Saturdays at 1 p.m. our Chess Club meets. Come test your skills. During the week we offer guided tours for teachers and their students. If you have a special need or are a teacher and want to take your students on a field trip to familiarize them with the resources of the library, we can help. Contact the Young Adults Department at [phone number] or e-mail us at [e-mail address] for more information.

Avoid filming an empty Young Adults Department. One of the draws of a Young Adult program is the opportunity to interact with other teens and have a good time. Show teens and activities in action to create excitement.

Testimonials add an opportunity to get your patrons involved. Find a teen who is willing to talk about Homework Help or any other service that you offer. There is nothing more powerful than a first-person account of how a service has helped someone. Here are some questions to help you get started:

- ▶ How did you hear about Homework Help?
- ▶ What do you think of the service?
- ▶ Would you recommend it to your friends?
- ▶ Do you come all the time or just when you find yourself stuck on a problem?
- ▶ How could we do a better job?
- ▶ Has this service helped your grades?

Describe Services for Adults

This segment is a catch-all for your remaining services. It will probably not be practical to list them all, so just choose a couple to highlight each week and create a series. My sample script focuses on book clubs, computer training, and legal resources.

Show Your Facilities

If your library offers unique spaces or rooms that patrons can use or rent, this is a good way to get the word out.

Sample Script: Services for Adults

Hi. Today we focus on three of our most popular services: book clubs, computer training, and legal resources. We offer a number of book clubs, where people can meet and talk. They are held at our branches and our downtown location. Check out our Events Calendar at [Web site address] for dates and times. We have clubs for many different genres, such as mystery, romance, and science fiction, and everyone is welcome.

We offer computer training at all our locations. Whether you are just starting out on a computer or need help creating a Word document or working on a spreadsheet, there are classes available. See our Events Calendar at [Web site address] for dates and times. All our computer classes require you to register beforehand, as the spaces fill up quickly.

Our Business and Technology Department is where you'll find the legal documents. We can't offer any legal advice, but we can direct you to the documents you need. If you have any questions, please call us at [phone number] or e-mail us at [e-mail address].

Sample Script: Facilities

The library has study rooms that can be reserved. Just call us at [phone number] or e-mail us at [e-mail address] to find out about availability. The rooms can seat up to six people and are specifically designed for students and researchers. All rooms come with a power source and free WiFi. For more details, go to our Web site at [Web site address].

The library has three meeting rooms. Each seats up to 50 people, can be custom configured to meet your needs, and is equipped with free WiFi, an overhead projector, a screen, and a microphone. The library offers these rooms at no charge to nonprofit organizations. Businesses and other organizations will be charged a small usage fee. For more details about room configurations and rates, see our Web site at [Web site address]. If you have any questions, feel free to call us at [phone number] or e-mail us at [e-mail address].

Film the spaces while they are both empty and in use. These shots will give viewers an idea of how the space functions and if it would work for them.

The stereotype of libraries as quiet tombs of books monitored by small armies of ssshhh'ing librarians is still out there. The best way to dispel this myth is to show what a modern, vibrant, and dynamic library now looks like.

Quick Checklist: Create a Library Services Tour

❏ Highlight the Children's Department
❏ Feature the Young Adults Department
❏ Describe services for adults
❏ Show your facilities

How to Create a Library Video to Address Internal Conflicts

If your library does not have internal conflicts and you don't have any politics, then you can skip this section. Until now we have focused mainly on the patrons, but if you, like most organizations, suffer from some level of dysfunction, then video can be a valuable tool to illustrate and defuse internal conflicts.

A couple of years ago, I created a series of videos that illustrated a conflict between information technology staff and librarians. We used the "I'm a Mac and I'm a PC" ad format (see Figures 3.17 and 3.18). The video emphasized that even though we have different perspectives and our focus is not always the same, we do have a common goal. That is to provide the highest customer service to our patrons, and only through working together is this possible (see Figure 3.19).

▶ Figure 3.17: Lighting and Camera Setup for the Series Called iACPL

▶ Figure 3.18: Example of Using an Infinite Background in the iACPL Series

▶ Figure 3.19: Trailing Caption Used in One Part of the iACPL Series

iACPL
Face it, we're all nerds here.

I find that humor is an antidote for tension among staff members. If we can laugh at ourselves and appreciate and respect the work of others, these conflicts can be reduced. Video can illustrate problems but can also demonstrate and model the correct behavior.

Understand and Define the Conflict

As an example, in some libraries there can be tension between the support staff and librarians. IT departments are focused on keeping equipment functional, secure, and up-to-date. Librarians are concerned with providing access and availability. Conflicts can occur when security collides with access. Another area where these two cultures collide is on issues of control, such as who has control over access and information.

Illustrate Conflict Resolutions

How can you illustrate a conflict and its resolution in a humorous way? Put on your creative thinking caps because this can be a challenge. What I do is look where there is conflict already and then imagine how funny it might appear if we placed IT staff and librarians in that situation. Examine the differences between the two scenarios.

Sample Scenario One

This scenario illustrates that internal fighting does not put the patron first.

Film a tug-of-war between IT staff and librarians, with both sides yelling out what's important to them. A patron walks up and is totally ignored. The caption is, "When we fight with each other, we lose patron focus."

Patron: Hey, what are you guys doing?

IT: Can't you see we are in a game of tug-of-war to decide who can edit this Web page?

Librarian: Everyone should have access. You guys are control freaks!

Patron: I was wondering if there is anyone around who could help me with my problem.

(Both IT and librarian staff stop pulling and look down at the ground, kind of embarrassed.)

IT and Librarian: We're sorry. How can we help you?

Sample Scenario Two

This scenario illustrates the concept of working together.

Film a paper ball fight between IT staff and librarians in the cubicles, where they are all throwing scrunched up paper at each other. A patron walks in, is hit by a piece of paper, and falls to the ground injured. The caption is, "When we fight internally, we only hurt the patron."

This scenario resolves conflict in a different way. The paper ball fight has gone on until a patron is hit by a stray projectile. This is when the fighting stops. Both sides realize what they have done and rush to help the fallen patron (who recovers, of course, because it was just a piece of paper). Both sides then work together to make sure that the patron is okay.

Communicate the Concept of Interdependence

Office politics are real, and interdepartmental conflicts do occur. Healthy organizations understand that they cannot function unless everyone does their job. Scenarios one and two show conflicts being resolved through interdepartmental cooperation.

Quick Checklist: Create a Library Video That Addresses Internal Conflicts

❑ Understand and define the conflict
❑ Illustrate conflict resolutions
❑ Communicate the concept of interdependence

How to Create a Video Annual Report

Traditionally, annual reports are printed, but there is no reason they cannot be created using video. Advantages include saving money on printing costs and reaching a larger audience through the Internet. It is green technology that does not require cutting down trees. Your staff can participate to produce it and tell their stories. Viewers may discover new things about the library. You have the chance to attract a new audience that might never have read the report but would be willing to watch a video. A video annual report captures a moment in time that is not possible on paper. People are much more likely to watch several small videos rather than one large one, so consider creating a series based on sections of the report.

> Columbus Metropolitan Library created an online interactive annual report. See it at http://ourstory.columbuslibrary.org.

Begin with an Introduction and Opening Statement

The director or assistant director will probably draft this script, and the director will present it. Begin the introduction by explaining why you are using this new video format. Then include some reflection of the previous year and a vision of where the library is going in the future. This segment should run two to three minutes.

State the Library's Values

What are the core values of your institution? Customer service and free access to information and resources? Establishing trusted relationships with customers? Create your own list of what makes your organization unique. Have some staff members talk about what these values mean to them. This segment can run two to four minutes.

Show What You Do

Throughout the year, capture footage of your activities and events. This will allow you to create a visual montage of your library. If you live in a seasonal environment, show different seasons to express the passage of time. You could also superimpose a calendar over the images to show what time of year they occurred. This segment can be a one-minute video montage.

Celebrate Your Staff

Have staff from every aspect of your library talk about why they work at the library and how they feel about the library environment. This is a

chance to celebrate your staff and acknowledge the work and expertise they bring to the library. This can be a two-minute segment.

Celebrate Your Volunteers

Show who your volunteers are and what they do. This will require planning, but take the time to interview them. Ask why they love the library and why they choose to volunteer their time. Volunteers are a great asset to any organization. Use this time to thank them and spotlight what they do. This segment can be one minute.

Celebrate Your Donors

Donors are vital to libraries. Here is a chance to thank them. You might not be able to mention everyone within the allotted time, but there are ways to visually recognize them. One is to superimpose a list of all their names behind the director while the director is expressing appreciation for their support. This segment can be one minute.

Celebrate Your Board

Boards are the overseeing body of most libraries. This is a perfect venue to recognize the work that they do. These are often volunteer positions, and people who serve on library boards are dedicated to both the library and the community. Capture some footage of a board meeting in session, and interview the chair:

1. Start by thanking the chair for taking the time for the interview.
2. Ask some specific questions:
 - What role does the public library play in our communities?
 - What are the biggest challenges facing our libraries?
 - What can our communities do to make sure this resource will always be available to them?
3. End by thanking them for their service.

These are often volunteer positions, and the people who serve on library boards are dedicated to both the library and community in which they live. This segment can be two to three minutes.

Give Your Financial Statement

Here is a chance to combine screencasting and video. Use screencasting to capture charts and graphs. Have the financial officer do the voiceover, explaining the diagrams and numbers. Then he or she can

talk in general terms about things that might have changed over the past year, some expectations for the future, and a financial forecast. End this segment with where to look on your Web site for full financial details. This can be a two-minute segment.

Quick Checklist: Create an Annual Report Video

❏ Begin with an introduction and opening statement
❏ State the library's values
❏ Show what you do
❏ Celebrate the staff
❏ Celebrate your volunteers
❏ Celebrate your board
❏ Give your financial statement

How to Film Teen-Created Content

What patron demographic has the most time, energy, and creativity, and is fearless when it comes to filming themselves? It's the kids. They will be the easiest to convince to make a library video (see Figure 3.20). Kids have no fear of technology. They are digital natives rather than digital immigrants, so don't be surprised that some will know more about technology and video production than you do. YouTube and other video hosting services are overflowing with films created by kids. I have watched everything from a 12-year-old electric guitar virtuoso

▶ Figure 3.20: Young Adult Department Review of *Paper Towns*

sitting in his bedroom giving Eddie Van Halen a run for his money to an 8-year-old giving technical advice on how to create a green screen.

Create Structure for Content

Until now we have talked about creating defined scripts and controlling the environment and what's happening. When working with teens, you want to retain a sense of fun and spontaneity. So, instead of giving them a script to follow for a book review video, just give a general outline:

1. Talk about the author.
2. Talk about the characters in the book.
3. Talk about why you liked the book.
4. Talk about why you think others should read it.

Another way to encourage and support teen talent is to display their art and film them talking about it. Start with an opening shot of a work, and then interview the artist. These interviews can be free form, starting off with questions such as these:

- ▶ I really like your work. Can you tell me what inspired you?
- ▶ How long have you been drawing?
- ▶ Have you ever thought about becoming a professional artist?
- ▶ What other artist or style inspires you?

Create a Video Production Space

It takes very little room and equipment to create a video production space for teens. If you provide training, access, and space, you will create an environment where they can be creative, share their ideas and thoughts, and just have fun. Ideas for teen videos include public service announcements (PSAs) for summer reading programs and game nights and book, movie, and video game reviews.

Quick Checklist: Film Teen-Created Content

❏ Create structure for content
❏ Create a video production space

Developing videos is the real "meat and potatoes" of this book. This is where you start to see the real applications for videos in your library and to get a feel for how you can create them yourself. These sections should enable you to create a repertoire of basic videos for your

library. If you want to get right to the nitty-gritty of creating videos, you could start here and get enough information to create your basic library videos.

▶ ADD QUALITY TECHNIQUES

Improve the Quality of Your Shots

Amateur video is easily recognized by its shaky, handheld quality. Using a tripod instantly improves your shot quality, but what are you going to do if you don't have a tripod or you don't have enough space to use a tripod? Here are some easy tricks. Lock your elbows into your sides; they should be pressing into your stomach slightly with your hands open, palms upward. Now lay one hand over the other, and you have created a solid platform for your camera to rest. If you want to create a low-angle shot, kneel rather than squat and use the same hand position. If you want a panning shot, then make sure that you have created a stable platform with your body and then twist your torso to the starting point of your shot and untwist the torso while you pan. The goal is to have a stable platform for your camera.

Steadicams

A tripod is a great piece of equipment and if you are filming static scenes such as an interview it is a perfect device, but what if you want something more dynamic and exciting? A library tour, for instance. How are you going to do that? The solution you most often see is that people will set up a camera on a tripod that captures a library department, and the speaker stands in front of the camera and gives a rather dry description of the department and its function. I call this the "Welcome to Our House of Books speech," and it goes like this: "Welcome to our House of Books. Inside our House of Books we have many fine books." This is followed by an awkward hand gesture indicating the department.

The other typical approach to filming a library tour is an amalgamation of the *Blair Witch Project* and every home video that your Dad made of you playing in the backyard. In desperation you grab your camera in your shaking hands and then follow your speaker as he or she talks. The shaking, rolling, homegrown results are probably not what you are after. You don't often see these kinds of shots in the movies, and you would be correct in thinking that film editors have spent hundreds of thousand of dollars in equipment to create beautiful

smooth panning shots. What might come as a shock is that you can spend about $20 and build your own steadicam (see this book's companion wiki), and this will produce results that are close to the professional footage you see in movies.

How do steadicams work? You need to understand a little about your body. When you walk with a camera, the jolt of your foot hitting the earth sends a vibration up through your legs and arms. Your brain understands this and compensates, so your vision seems steady. Actually, your brain is doing some pretty amazing things when you start looking at vision. Unfortunately, your camera doesn't have a brain, so you have to find a way to remove the unwanted motion.

All a steadicam does is extend the center of gravity outside of the camera. The center of gravity is best illustrated by taking a ruler and balancing it horizontally on your finger. There are three axes at work here, X, Y, and Z. The point where they meet to achieve balance is the center of gravity, sometimes also called the "center of mass" (see Figure 3.21). If you have a tripod, try this experiment. Attach your camera to the tripod and extend the legs downward a little. Now balance it horizontally on your hand exactly the same way as you did with the ruler. Mark this point on the tripod with a piece of tape. This is the center of gravity. Turn on the camera and hold the tripod at this point and walk around. Notice how much smoother the video has become.

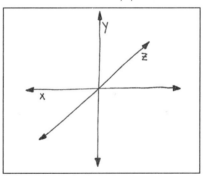

▶ Figure 3.21: Center of Gravity at the Balance Point of the X, Y, and Z Axes

Camera Dollies

Camera dollies are devices that help create a smooth panning shot. Generally they are a platform with wheels that run on a track where a camera and tripod are mounted.

How can you create an inexpensive imitation of this effect? When doing interior shots, try placing the camera operator in a chair that has wheels and have someone slowly pull the chair around. This works well if you are on a hard surface and you are filming a subject walking or running toward you. We used this technique when filming our "Reference Zombies" video where two actors ran down the book stacks looking for a book to help them fight off zombies.

Another approach is to find a furniture-moving dolly and have your camera operator stand on the platform. Moving dollies have the advantage that the wheels are larger and the shot is smoother. The disadvantage is that the person operating the dolly has to concentrate on not raising or lowering the camera.

For low-angle dolly shots, try mounting your camera on a skateboard.

Scene Setups

The Standing Interview

Interviews are best when both you and your guest are seated. This stops the guest from moving around and going off camera. It increases the level of focus on the guest and makes for a better interview. Sometimes this is not possible—maybe you're outside or there just isn't enough space to place furniture. Follow these guidelines: The host is the person who talks directly to the camera, and the guest talks to the host. The host stands at an angle to the guest. This allows the camera to stay stationary and get a three-quarter-profile shot of the guest, which is more attractive than a full profile. This setup allows the host to turn back to the camera to do the introduction and exit (see Figure 3.22).

The Sitting Interview

The challenge is that you have one camera but want to have a number of shots. You don't want to sit the chairs side by side, because when the host and guest talk you will be shooting both profiles. You do not want to have them facing each other, because this causes the same problem. The best option is to shoot over the host's shoulder. This gives you three shots: the wide angle, midrange, and close-up (see Figures 3.23, 3.24, and 3.25).

As you are filming the interview, you do not need to microphone the host. The reason not to microphone the host is because after the guest leaves, you will move the camera and have the host ask the questions again. This allows you to focus on getting the best audio quality for both the host and the guest.

Remind the host to leave time for the guest to answer the questions fully and not interrupt. Having a host interrupt or interject a comment in the middle of an answer has a couple of undesirable effects. It breaks the guest's train of thought, and it will make editing difficult in post-production. The host should talk as little as possible.

▶ Figure 3.22: Recommended Positioning for a Standing Interview

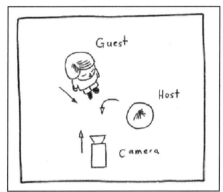

▶ Figure 3.23: Recommended Positioning for a Seated Interview

▶ Figure 3.24: Midrange Shot, a Common Camera Angle for Interviewing

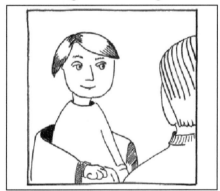

▶ Figure 3.25: Close-Up Shot of the Subject

You want to have your guest's attention on the host and not on the camera. The host can help by engaging the guest in nonverbal communication like nodding and smiling. If there are lights on the front of the camera, cover them with black electrical tape.

Decide on which side of the screen the guest is going to appear. This needs to stay consistent throughout the interview. Discontinuity of having the guest appear on the left and then the right side will confuse the audience and make it appear as if the guest is interviewing himself. After the interview has ended and the guest has left, you will need to reposition the camera and microphone the host.

Before you film again, go back with the host and view the footage. Then have the host ask the questions again and any new questions that will work with the interview. Ever wonder how a host can ask just the

right question? Well, this is how it's done. You also want to capture some reaction shots. These are the non-verbals such as thoughtful, listening, or serious expressions. You will be able to use all these shots when you start the editing process.

Lighting Fundamentals

Lighting is about creating illusions and involves the camera's eye rather than the human's eye. Remember, what we are fundamentally doing is taking the three-dimensional world that our eyes and brain understand and translating it into a two-dimensional image. Good lighting is key to making this happen.

Most likely much of your filming will be done in public buildings, which are usually not lighting-friendly environments. Fluorescent bulbs are generally used to light public buildings, and they cast a low-level green light from overhead.

You can use natural light to illuminate your subject whenever possible. Place a chair by a window and let the light fall on your subject's face. Film in the morning or evening; this creates a dramatic look, and the light at these times of day is soft and diffused. To improve your lighting, create your own lighting kit (as described in Chapter 1).

Before you start setting up your lighting, keep a few simple elements in mind. Exposure is one. Most cameras have a built-in light meter and will show a flashing or crosshatched area to indicate overexposure. You may have to adjust the camera to prevent overexposure. Another is contrast. Unless you are trying for a high-contrast look, a good rule of thumb is to avoid white. This means white backdrops, shirts, and objects. The goal is to have the lighting range within the camera limits. You will need to light shadowy areas and lower the levels of highlights. Light levels are reduced to a quarter when distance is doubled. In other words, twice the distance means a quarter of the light. You can see the relationship in Figure 3.26, where r equals distance and I equals intensity.

▶ Figure 3.26: Relationship between Light Intensity and Distance

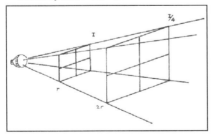

Anyone can use a Webcam and press "Record." Lighting is the tool that affects the quality of the image. As you start creating videos for your library and posting them on the Internet, you want to avoid the

Basic Lighting Setups

The following three basic setups use from one to three lights and a reflector board. You can adjust them to play with lighting variations. In each setup, I used the diffuser (i.e., a shower curtain) to show the different effects of soft and hard light. The companion wiki contains photographs of the setups used, and some photos demonstrating the lighting effects.

Setup 1: This quick and easy setup uses one light and a reflector board. It is ideal for an interview (see Figure 3.27).

▶ Figure 3.27: One Light Source with Reflector

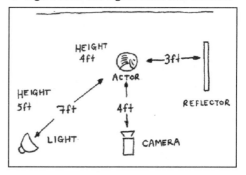

Setup 2: This setup adds a light directed to the right-hand side of the face. With this setup, we can get more definition and balance the image (see Figure 3.28).

Setup 3: This setup uses three lights and no reflector board. We start with our key light, and then add fill and backlighting. Because we are using scoop lights and want less light from the fill and backlight, we will move them a little farther away. This will create modeling on the face and a better lighting ratio. The key light needs to be facing downward into the subject's face. Be careful not to make the angle too acute, as this will cause shadowing problems. The fill light should be at face level and start with the backlight pointing at the base of the neck. The goal of the backlight is to separate the background from the subject. If the backlight hits the top of the head it will create shadowing problems, and you will not get the desired effect of separation (see Figure 3.29).

▶ Figure 3.28: Two Light Sources with Reflector

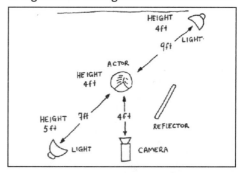

▶ Figure 3.29: Three Light Sources with No Reflector

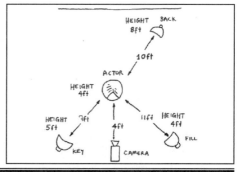

homegrown look and feel of a Webcam production. Most of your time will be spent lighting the face, because this is where your viewers are going to be focused. A dark backdrop or background will help hide unwanted shadows, and it has the effect of focusing the viewer on the subject.

Create a checklist of all your equipment and include spare bulbs, batteries, and duct tape. Before you go to your location, go through your equipment and make sure you have everything on your list. Be prepared for something to fail or break.

Allow enough time to set up your lights. It takes about one to one and one-half hours to get everything tuned and ready. Get a coworker to stand in as your lighting subject so you won't have to keep the person you're filming waiting as you fiddle with lights and camera location. If you have a digital still camera, take pictures of your stand-in to check lighting levels.

Camera Angles

The following are the camera angles with which you should be familiar.

▶ Figure 3.30: High-Angle Shot of Kay in Her Cubicle

High angle: This is the point of view of an authority figure. You may be trying to show fear and apprehension, and the angle can be loaded with emotion and tension. In Figure 3.30, Kay is cringing and has her arms and hand drawn into her body.

▶ Figure 3.31: Low-Angle Shot of Bob

Low angle: This point of view is the reverse of the high-angle shot. It can be used to show power, strength, and control. In Figure 3.31, Bob is doing a wonderful job of looking menacing. He is dressed in black with arms folded. You can use this angle to communicate all types of emotion without relying on dialogue.

Eye level: Most of your footage will be shot at this angle. It is the perspective that you have as a person and how you experience the world.

Bird's eye: This makes for a dramatic shot. We used this angle in our movie "Reference Zombies." It is typically a challenge to create. For "Reference Zombies," we took advantage of our building's architecture and used the second-story balcony to shoot a bird's-eye angle (see Figure 3.32).

▶ Figure 3.32: Bird's-Eye Angle

Slant: This is where you tilt the horizon line from level. It is the sledgehammer of angles and can be disorientating for the viewer. My advice is to use this at pivotal moments rather than throughout the film. Don't take my advice and you could find yourself accidentally producing a bad 1980s music video (see Figure 3.33).

▶ Figure 3.33: Slant Angle

Point of view: This is shot at eye level but from the point of view of, for example, a zombie chasing someone (see Figure 3.34). In a chase scene, it provides the feeling that someone is about to be caught. It is a chance to have fun and to be creative with your angles. It's perfect for a library tour to provide viewers a realistic perspective of navigating through your building.

▶ Figure 3.34: Point-of-View Angle

Close-up (one person talking to the audience): When you are creating an informational piece, the close-up angle is an important tool. It creates intimacy and trust within the viewer. This happens because you have placed the viewer inside the speaker's personal space.

Start Filming and Edit Your Work

You cannot edit what you have not filmed. You need to get all your shots, and the best way to do this is to follow the shooting sequence (see Chapter 2) you created, including the checklists for your camera angles and other elements that you want to include.

When to Edit

Editing is about advancing the story, so whenever there is new information you should look to edit. Continuity is intrinsic to storytelling, and the edits should gently lead the viewer along. Be careful not to disrupt the spell that has been cast. As an example, in the Rock Band video discussed earlier, we want to show that the band is getting ready to go on stage. This could be done with a quick edit of them getting ready to leave, but a hard transition from cubicle to stage would create discontinuity for the viewer and might have a jarring effect and interrupt the storyline.

Interview Editing

If you are interviewing someone or trying to capture a conversation, a good approach is to edit back and forth. The goal is to have the edits follow the conversation. This creates a natural pace and timing. The audience can see reactions and emotions. If you were to edit with both speakers in the frame and did not edit away from that shot, you have inadvertently created a static feeling that is at odds with the lively conversation you've filmed.

Audio Editing

Each video edit has an accompanying audio edit. One technique that improves the overall quality is to offset your dialogue and footage. There are two ways that this can be done. Either have your sound track extend over your video cut in the left-to-right direction, or do the reverse and have the sound track extend over the video cut in the right-to-left direction. Editing the dialogue so it will sound natural is going to take some time. One trick is to close your eyes and just listen to the sound track. Resist the urge to edit on the verbal pauses. There is no correct way to edit; it is basically a matter of trial and error and what sounds good (see Figure 3.35).

▶ Figure 3.35: Editing Audio and Video at Different Points to Create a Sense of Continuity

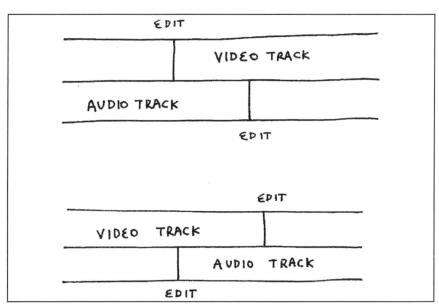

Ruthless Editing with Style

If it doesn't advance the story, it needs to go. You will generally have far more footage than you can use and will be faced with the task of deciding what to leave out. There is no magic editing formula to follow, but here are two suggestions.

Sit down with your notebook and watch the footage a couple of times. Take notes and begin to think of shot combinations you want to use. The way that you combine your shots is important, because you want to capture reactions and emotions. Even with a public service announcement or interview you want to have emotional content. It might be a smiling, welcoming introduction or a thoughtful answer to a question in an interview.

There is no magic formula to correctly edit, but there are some suggestions. Group footage into three sections: material that might be at the beginning, middle, and end. These techniques will help you turn your ideas into a more structured and higher-quality video. By taking a basic video idea and adding standard angles and shots, appropriate editing, good lighting and other techniques, you can start to improve the quality of your videos greatly, with little or no cost. This is what dif-

ferentiates the real videographers from the person with a camera and an idea.

▶ ADD IMAGINEERING TECHNIQUES

Imagineering is "The art of telling a story on a tight budget." Here is a collection of ideas that I hope will fire your imagination and help you find new and creative ways to tell your story using video. See this book's companion wiki to watch my videos that illustrate the techniques referenced in this section.

Animation

The blessing and the curse of animation is that you have total control. There is no spontaneity, and you are responsible for every detail. The good news is that there is some amazing software available that makes the process fun and easy.

Reallusion is a company that produces some outstanding three-dimensional (3D) animating development tools. iClone and Crazytalk are stunning products but run only on the Windows platform. iClone allows you to create 3D actors and environments, including sky, water, and landscapes. Actors can interact with their environment. The lighting feature alone will allow you to experiment with every light situation you could imagine. As a bonus, iClone is designed to work with Google's free 3D modeling tool called SketchUp. SketchUp allows you to draw any object you can imagine. A large community of artists use SketchUp, and Google has a library of objects that you can download for free if you are not up to creating your own. Google's tutorials will teach you step by step how to use the program. Another useful tool is 3DXchange, which is needed to import models from Google's 3D Warehouse.

Crazytalk is a face puppet animation tool. You can capture a face in a variety of ways. You can create a simple line drawing, shape a face using a 3D modeling tool, or capture an image using a camera. Once the image is caught, it goes through a face-fitting process that places it on a grid. This allows you to map facial features like the eyes and teeth. The software allows for automatic lip syncing from an audio track, and you can add head movement and expressions.

Reallusion offers educational pricing for schools, but I have found that if you contact either the company or the distributor, they will extend this to libraries. The price point for Crazytalk, iClone, and

3DXchange is $300.00 for each, but call and see what kind of deal they might give you.

Anime Studio is a 2D animating tool that is feature rich but will require a little time to learn. It has a lip-syncing module and a bones system that allows you to place bones within your character to help animate movement. Figure 3.36 shows a character I created from a simple line drawing and scanned and imported into Anime Studio. To improve the quality of your import, convert your line drawing to transparent .png files rather than .gif.

▶ Figure 3.36: The Bogeyman Character Created to Praise the Library's Online Services

Sample Script: Bogeyman Animation

In my busy life I don't get out as much as I would like.

(Foley: Tapping away at the keyboard)

Being able to access the library from home is convenient and fun.

I can renew books, place holds, pay fines, ooooo . . . and now download audiobooks.

E-mail notices tell me when my holds are available, so I can go in when it's convenient for me.

(Foley: Footsteps coming to the door)

Well, I got to go. See you tonight!

The only thing animated in the Bogeyman film is the mouth and the eye. When first starting to animate, keep it simple and focus on the story. Falling in love with the technology is a trap; remember, it is only there to support the message.

Paper Dolls

I have drawn three paper dolls and will use photographs of staff for the heads (see Figures 3.37, 3.38, and 3.39). This allows me to capture expressions and reaction shots without having to worry about location, lighting, camera angles, talent availability, or costuming. If you don't have the time or inclination to make your own, paper doll cutouts can be easily purchased.

▶ Figure 3.37: Paper Doll Figure 1

▶ Figure 3.38: Paper Doll Figure 2 ▶ Figure 3.39: Paper Doll Figure 3

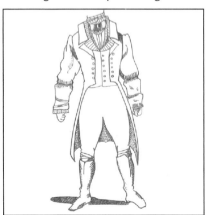

Finger People

Don't let a limited budget stifle your creativity. The finger person shown in Figure 3.40 was used to give a brief introduction of a library event. What I like about finger people is that it is easy to change their emotional state with a little soap. If you are short on time and you need to quickly create a video, finger people can be a great solution. They are fun and will provide a touch of humor.

▶ Figure 3.40: Finger Person Created with Thumb and Ballpoint Pen

Stick Drawings with Voiceover

This approach is a simple, fun, and effective way to tell a story or express an idea. One of our branch librarians had drawn a series of stick figures to use when talking to her staff about various customer service issues. We captured these images and then recorded a voiceover (see Figure 3.41).

▶ Figure 3.41: Stick Figure Drawing of an Angry Patron

Puppetry and Costumes

Using puppetry is another lighthearted method to convey information. It sends the message that libraries are fun, challenging an old stereotype (see Figure 3.42).

Figure 3.43 shows an example of how we have used costumes. Lily the mouse is interviewing our director.

Stop Motion Animation and Claymation

This animation technique is where an object is captured in a frame and then moved slightly and another frame is captured. At the end of the process the frames are stitched together. The stitching together of frames results in the object becoming animated. It is the same princi-

▶ Figure 3.42: Melissa Using Puppets in an Episode of "What's Happening"

What's Happening March 2, 2009

▶ Figure 3.43: Lesley Dressed Up as Lily the Mouse to Interview the Director

ple as flip books, but instead of using physical pages we are using frames of film.

There are a couple of really easy and cheap ways to play with stop motion. Claymation is the art of creating characters in modeling clay and then using stop motion techniques to animate them. Modeling clay can be purchased for a couple of dollars from your local art store.

This medium allows you to create any type of character that you want. You are able to shoot in a very small environment. One advantage with this type of filming is that you can step away and take a break. It allows for a much more flexible shooting schedule.

I had never done this type of animation, but I was interested in seeing just how much time this would involve. I had always had the impression that this was a very time-intensive process and that film creators in this style would labor for hundreds of hours just to capture seconds of footage.

I decided to see how long it would actually take me to create a simple stop motion animation using clay. After I purchased the clay it took me about 20 minutes to mold a figurine that I was happy with. I then set up a still camera on a tripod and captured about 200 photos of the figure walking across a desktop and climbing onto a book. Capturing all the images took about 30 minutes. I then imported the photos into Windows Movie Maker and added them in bulk to the timeline and hand-edited each still. This took about an hour. I threw on a title and added some music (see Figure 3.44). In all it took about two hours' work for about ten seconds of footage.

▶ Figure 3.44: Creature Made from Simple Modeling Clay

Here are some tips for claymation. Oil-based clays are best for animating and are non-toxic. Some clay will stain surfaces so put down some protective paper on your tabletop. It is important to secure your tripod. One approach I have seen is to tape the tripod's legs to the table. I did not do this but I was careful when capturing frames.

So how many frames do you need to capture? A good rule of thumb is that you will need to capture ten frames for every second of film. If you make a mistake, don't worry, just delete the photo in your camera and retake the shot. I recommend doing this because when you import your frames into your video editing software it is going to be easier just to import all the needed frames in the order you want them. Cameras vary on how they export photos but to keep your sanity, I would create a new album or folder and store your photos there. This helps when you are keeping track of a number of projects.

The timing that you choose will affect the speed and duration of your film. A good place to start is to have three frames per photo. The reasoning is that there are typically 30 frames per second for regular video footage and this way you will have 10 photos for 30 frames and be at the same rate. Again there is no absolute rule and on my first test I just played around with the frames until I got the tempo I wanted. You can decide if you want to take a deterministic or heuristic approach.

The next step will save you a ton of time if you are using iMovie. Select all your photos in your album. The easiest way to do this is to click on your first image and then while holding down the shift key click on the last image. This will select all the images in your album. Click on the "Show Photo Settings" and enter 0.03 for the duration. Click on the apply button and your photos will be imported into the timeline.

If you want to add interest to your piece, you can mix stop motion with regular footage. There is an award-winning video on YouTube called "Between You and Me," which is a short video showcasing what is possible in stop motion.

iStopmotion is available for the Mac. It is a simple program that both kids and adults can use. It has a great feature that lets you create a flipbook. I could easily see this used in a Children's or Young Adults Department to introduce kids and teens to animation. David Pogue from the *New York Times* has created a video of his nine-year-old son creating a video. You can access the video from either the iStopmotion homepage or the *New York Times* video section at video.nytimes.com under the Technology section.

If clay doesn't awaken your desire to animate, another approach is to draw a figure but segment the arms and legs. You can use the same technique as you would with clay but you would just be working in two dimensions. Figures 3.45 and 3.46 show how I have used this to animate the character in a number of interesting ways,

Green Screens

So what is a green screen? Green screens are used on a technique called chroma key. This is where you take some or all of the background and replace it with a new image. The way that you do this is to make the background a single solid color. In most instances this color is either green or blue. It is most commonly called a green screen effect.

Once you make your background green and you have filmed your footage, you can tell your editing software to make everything that is green transparent. This can be done in post-production or in real time. You will most often see newscasts use this technique in real time.

I have seen libraries install a permanent green screen in their Young Adults Department. It makes for a fun and interactive program!

Building a Green Screen

Any kind of background will work. I found a plastic green tablecloth at a local Mega Market for $1.00 and then used duct tape to attach it to a couple of 2" × 1" boards that I had in the garage. Other alternatives I have seen for material to create your own green screen are poster boards or felt fabric. You could also use a green wall. It does not really matter what tone of green you use, but most often bright green is chosen because it is the easiest to identify and remove.

▶ Figure 3.45: Caption: Initial Drawing of the Character I Plan to Animate

▶ Figure 3.46: Caption: Segmented Character That's Now Ready to Film

There are a couple of things you need to be concerned about when creating your background. Make sure that the backdrop is smooth and you have removed as many wrinkles as possible (see Figure 3.47). The other concern is lighting.

Lighting a Green Screen

You can add a number of lights to remove shadows, but this is not necessary. You can create a simple, workable, green screen by using just two light sources. In Figure 3.48, the light is coming from the left-hand side and other light is from overhead.

You can see how I have set up my lighting in Figure 3.47. One issue I ran into was the shadow of the chair. When lighting, make sure that there are no shadows on the green screen, as these will be hard to remove. I am still using a standard definition camera and no microphone. The setup time was about 30 minutes. I would recommend doing some testing with the background and also some screen tests to determine what will work before you go into production.

Figure 3.49 shows some of my first test footage. Things that I need to look for in the future are shadowing and background inconsistencies. Here we can see wrinkles on both the left and right sides of the subject, and there is color alteration on the edges. These are going to be diffi-

▶ Figure 3.47: Green Screen Studio

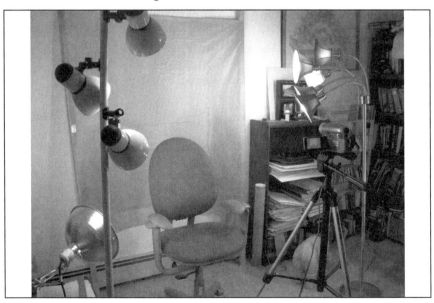

▶ Figure 3.48: How to Light a Green Screen

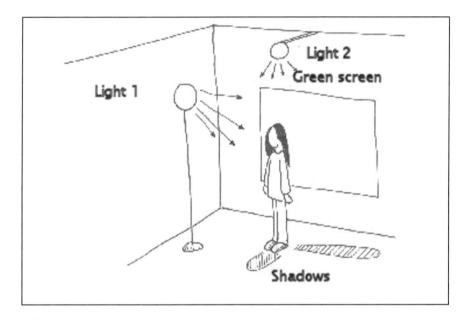

▶ Figure 3.49: Green Screen Test Footage

cult to remove in post-production. The shadowing can be solved with an alternate lighting configuration and adding tension to the screen to relax the creases.

Figure 3.50 shows the final result. I was hoping to find that either iMovie or Windows Movie Maker could easily do chroma keying; however, this is not the case. I believe it is possible with iMovie 9 or above. For chroma keying, I use a free software package called Wax.

Chroma Keying Using Wax

There is a free software package called Wax that you can download from www.debugmode.com/wax. It is a video special effects software package and runs on the Windows platform.

On this first screen test I found that I couldn't make all of the background transparent due to the color variations from the wrinkles and shadows on the screen. The solution that I came up with was to find a green photo that I liked on flickr.com, one I thought would work as a background. I then imported it into Corel Draw and altered the size so that it would completely fill the background in my view. You can see some of the problems in both the left and right bottom corners.

Let's walk through the steps you need to perform to get chroma keying to work using Wax (see Figure 3.51).

▶ Figure 3.50: Final Green Screen Image

▶ Figure 3.51: Wax Desktop Window

Import your green screen video footage. This is done by positioning the mouse in the window called Media Bins and right-clicking. A pop-up window will appear and you will choose "Add Media Files." Now locate the footage that you have created.

Wax can natively import AVI video and WAV audio. You may need to convert your video footage to the correct format (see Figure 3.52).

Your footage will now appear in the opposite window. Select both your video and audio tracks and drag them down to the timeline. The timeline is located in the bottom right (see Figure 3.53).

Find the place where you want to start your video. Go ahead and do your editing now. It is easy in Wax, as you can just select and drag your footage in the timeline. You will also want to edit the audio track so your video and audio match.

Once the editing is complete you can move these edited segments to the beginning of the timeline.

To start, let's just add an image that will be our background. It is possible to add video footage but let's keep it simple. This is done the same way. Go to the Media Bin section and right-click the mouse.

▶ Figure 3.52: Wax Desktop with Imported Files

▶ Figure 3.53: Wax Desktop with Video in Timeline Ready for Editing

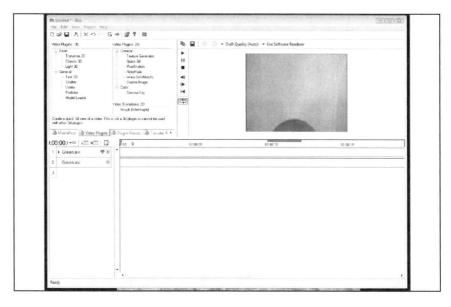

Choose "Add Media Files" and drag the image down to the timeline below the previous tracks.

Expand the picture to match the duration of the audio and video clips that we have already edited, so the picture will appear in the background for the entire duration of the video.

On the left-hand side of the window opposite the timeline select the video file and then directly above click on "Video plug-ins."

Drag the Quick 3d effect that is under the Video Plugins 2D onto the video footage file on the bottom left window. It should appear to be indented under the .avi file if you have dragged it correctly. This is going to allow us to crop away most of the green screen that we don't need. Expand the Quick 3d plugin by clicking on the triangle and scroll down until you find the crop options: Crop left, Crop right, Crop top, Crop bottom. Crop away the areas that are not needed; this will help when performing the chroma keying later in the process. After you have finished cropping check your footage to make sure that you have not cropped too aggressively (see Figure 3.54).

▶ Figure 3.54: Wax Desktop with Chroma Key Effect

Position X and Position Y will allow you to move your cropped image to the correct position on the screen. Now minimize the Quick 3d plugin by clicking on the triangle.

Now select the chroma key plugin and drag it on top of the Quick 3d track. You will see the option called color. Click on the eyedropper and select the color from the green screen portion of the video that you want to make transparent. You should see that the color changes.

Now slide the tolerance counter slowly to the right and you will see that the green slowly becomes transparent and eventually eliminates the green (see Figure 3.55).

Now is a good time to save your work. Let's render the project. First click on Project on the top menu bar and then the options button. Here we are going to be setting the compression options. You can choose the rates that you want both your audio and video compressed. Now go back and choose Project and render. You are now done!

▶ Figure 3.55: Wax Desktop with Final Background Added

Quick Tip

Rendering takes your native video footage and allows changes and effects to be added in the editing software. You need to render again to incorporate these changes into a single video stream.

Advanced Imagineering Techniques

Once you've mastered the basic building blocks of shooting videos, you're ready to explore some more advanced animation and imagineering techniques. Start by visiting this book's companion wki. There you will be introduced to:

▶ Time-lapse video
▶ Pleasantville effect
▶ Picture-in-picture effect
▶ Letterboxing
▶ Explosions

Imagineering, the implementing of creative ideas into practical form, is where creating videos starts to expand beyond the basics. These animation and imagineering techniques are all within your ability and I hope you experiment with them, as I have. Imagineering is where you go from reality to the limits of your imagination, and it is as easy as playing with clay.

▶ CREATE THE FINAL PRODUCT

Post-production is when you add titles, captions, credits, fades, edits, and sound effects. It is also when you compress the videos and/or save them in different media formats.

Beginnings and Endings

You want to capture the viewers' interest with your opening shot and draw them into the scene. Start with a wide shot to a midrange shot to the close-up. Use the reverse as your ending, close-up to middle shot, ending with the wide shot. The classic fades are fade in from black to begin and fade to black to end. This effect creates the illusion that time existed before the moment we are watching and that time will continue on after we end. These are unobtrusive effects that appropriately encapsulate your work. Another trick is to freeze the final frame

as you fade to black. This image will stay with the viewer and is a nice way to put a punctuation point at the end.

Titles, Transitions, and Credits

Add titles and credits to every piece of video you create. These simple touches give quality to your work and set it apart from others. There are many transitions you can use to move smoothly from the title to the start of your video. It is tempting to go a little crazy with these effects, but subtlety is a virtue. The transitions I use most are the fade-down from the title to the fade-in as you start your film. Most editors use these two transitions, because they are clear and unobtrusive. The rule is that transitions should be seen and not visually heard.

Foley

Foley is the technique of adding sound to a piece of footage. These can be sounds that you failed to capture or sounds that were not readily available while you were on set. Adding these sounds gives ambiance and audio texture to your work. Examples are the sound of running feet or the squeak of a door opening slowly. One of the effects that we use in our library videos is to create an audio sense of quiet. You cannot create the sense of quiet with merely the absence of noise; you create it by having sounds that you hear only when it is very quiet, such as the click of fingers on a keyboard, the ding of an elevator bell, or the sound of distant footsteps.

You can use natural sounds to add humor. Here is an opportunity to take a tired stereotype and breathe new life into it. Imagine filming a library tour. The viewer is expecting a dry, taciturn voyage through the stacks. How about presenting in a manner that is unexpected, where the guide giving the tour goes from department to department at super speed accompanied by the sound of footsteps that are inhumanly fast? Every hand gesture is accompanied with a whoosh as if a martial art expert is cutting through air. The tour is now informative, engaging, and humorous.

Add natural sounds after the video and dialogue editing is complete. For greater control, add the sounds as an individual channel. You want to coordinate the sounds with the footage, and the easiest way to do this is to watch the footage while capturing the sound. Capture the sounds in a controlled studio environment to avoid ambient noise that might intrude.

Here are some sounds you might want to add to your video:

▶ **Fingers clicking on a keyboard**: Place a microphone close to the keyboard while fingers tap the keys.

▶ **Footsteps on a hard surface**: Use a pair of women's heels on a hard surface or a pair of men's shoes, depending on the actor. Even though the female might be wearing a soft-soled shoe, it is acceptable to introduce a heel sound.

▶ **Doors opening and closing**: Place a microphone close to a door when it opens or closes.

Have fun with these effects, and remember that less is more. Sound effects should add, not distract.

Video and Audio Compression

A video compression device or program is called a "codec." This stands for compression/decompression and code and decode.

Initially when your camera is filming it is taking an analog signal, which is light waves, and then converting it to ones and zeros. Before there was digital it was taking the analog signal of light and exposing it on film that had to be processed. Now a codec (coder/decoder) is used to perform this conversion. The common recording formats are HDV (high-definition video), DV (digital video), and AVCHD (advanced video codec high definition). You will do most of your editing with one of these.

Why is codec important? These (HDV, DV, and AVCHD) video files are much too large and need to be converted and compressed again to be delivered quickly over the Internet.

The goal of codec designers is to compress the file without losing any other audio or video quality that the viewer perceives. Remember that through the process of compressing you are losing image and audio quality. Once your file has been uploaded, the online host may encode and compress it again.

The trick is to always move from a higher codec to a lower codec, never the reverse. The codecs handle compression in different ways, and they are not always equivalent. Sometimes the difference is quite noticeable. In the computer world this would be equivalent to .zip files and .gz files. They both compress the file, but they use different tools to do the compression and decompression.

Do not confuse media container formats with video compression formats. Media container formats hold both audio and video once they have been compressed. An example of a media container file for-

mat is AVI, whereas MPEG3 and MPEG4 are compression formats, and they require a codec to understand the format.

Your video editing software should have multiple export options to change your video codec. Some of the editors are even preset for video hosting services. If you are uploading your video to YouTube, a good place to start is by uploading using MPEG4 at 320 × 240. After that you can experiment. Just remember that once it gets to the video hosting site it will probably be converted to Adobe's Flash Video; this is the most compatible codec and is recognized by the most browsers.

The more you understand about compression the better your video quality will look. If you want more control and are interested in investigating compression further, take a look at Sorenson Squeeze, Adobe Media Encoder, and Apple's Compressor.

Video Converters

You can download a free converter from the Internet. Two examples are Audio/Video and Any Video Converter. They are both available at http://download.cnet.com.

I recommend downloading both because I have found that as I work on a project I have to convert the format to use different tools. This happens, for example, when I do video production on both a Mac and a PC using Movie Maker (PC) and iMovie (Mac). Movie Maker works only with the WMV format, but I really like some of the features that iMovie offers but Movie Maker doesn't. iMovie comes with a library of background sounds and has some really nice title features (for details on PC to Mac conversion, see "Convert Files for Mac Users" in the next section).

Another example is that I often use different equipment to capture video. Sometimes I use a camcorder or a still camera or even a phone. Each of these saves the video in varying formats, so again I need to convert.

Making Your Videos Accessible to Users

Upload Video in HD to YouTube

For the best results, YouTube recommends that you format your video using MPEG4. YouTube accepts a wide variety of formats, such as WMV, AVI, and MOV, but then YouTube translates them and you will lose some quality.

YouTube also recommends H.264 and MPEG2:

- ▶ Set resolution to 1,280 × 720 (16 × 9) for HD and 640 × 480 (4:3) for SD.
- ▶ Set audio at 128k mono or 320k stereo MP3.
- ▶ Use 24 or 30 frames per second.
- ▶ Upload at the same rate that you recorded the footage.

How do you force your YouTube video to always play in HD? This is done simply by appending one of these formatting codes to the end of the URL:

&fmt=6: Increases the resolution from 320 × 240 to 448 × 336
&fmt=18: Increases the resolution to 480 × 360
&fmt=22: Increases the resolution to 1,280 × 720

I achieve my best video results by recording with the above recommended settings and then appending &fmt=22 to the end of the YouTube URL.

Embed Video in HD into Your Blog

To embed into your blog, pull up your video in YouTube. On the right-hand column you will see the thumbnail image and the URL and embed script. Select and copy the embed script. It will look something like this:

```
<object width="560" height="340">
<param name="movie"
  value="http://www.youtube.com/v/YxfzapIF-CQ&hl=en
  &fs=1">
</param>
<param name="allowFullScreen" value="true"></param>
<param name="allowscriptaccess" value="al-
  ways"></param>
<embed
  src="http://www.youtube.com/v/YxfzapIF-CQ&hl=en&f
  s=1" type="application/x-shockwave-flash"
  allowscriptaccess="always" allowfullscreen="true"
  width="560" height="340">
</embed>
</object>
```

You are going to need to make some changes to the code. There are two instances of **hl=en&fs=1** in the script, and both need to be changed to **ap=%2526fmt%3D22**. Now you can embed the edited script into your blog, and it will always play in HD.

Convert Files for Mac Users

Recently I purchased the Vado HD flip camera and wanted to edit some of the footage on my Mac. There were a couple of challenges that I encountered, and you are likely to experience the same sorts of problems as you go forward. The Vado HD records in AVI H.264 at 1,280 × 720. Neither iMovie nor Final Cut Express will read this format, and my version of Final Cut Express did import the file but would not render the video.

ffmpegX solved the problem on the Mac for me. This shareware package is a lifesaver. If you like it, pay the $15.00 price tag. It's worth it. To use ffmpegX, just drag your file to the "Drop file here" section of the window (see Figure 3.56). I have set my target format to *.mp4.

▶ Figure 3.56: Encoding Screen Where Files Are Dropped and Encoded

Use a Streaming Video Service

Ustream.tv is a free Internet service that allows you to create streaming video content and broadcast it directly out onto the Web. It is amazingly simple to get this up and running. The first thing you need to do is create an account. Then, with a laptop, Webcam, and Internet connection, you are ready to broadcast. Creating a show is as easy as logging in and clicking on the "My Show" tab. You will need to create a title for your show and attach some tags and a brief description. After you have filled in these fields, click on the "Broadcast Now" button. If you have a Facebook account it will automatically notify your friends that you are now broadcasting. A built-in function will also notify your Twitter friends.

I used a MacBook and its built-in camera and audio. Ustream.tv recommends that you have a 320 Kbps upstream link, but I tested it with a WiFi connection and there was some delay but it was very workable.

The display is 416 × 340 and can be expanded to full screen. The image degenerates in full-screen mode, however, which is to be expected. You can archive your shows on your Ustream.tv account, but the really attractive feature is that you can also automatically archive them to your blip.tv account.

Another helpful feature is that the iPhone has a free Ustream.tv application. The application on your iPhone allows you to search and browse through content. This application works on WiFi networks but does not yet work on a 3G network. I imagine that it is only a matter of time before it will work on both.

What I really like about Ustream.tv is that is has a built-in chat client so people are able to watch the presentation and send comments in real time. This means that viewers can interact with the program and each other. This type of technology allows for a backchannel of communication that can be captured along with the video footage. The information is no longer confined to a lecture while a passive audience listens. This technology promotes interactive discussion, which makes for a richer overall experience.

Ustream.tv has a pay-as-you-go option to access a set of advanced reporting and monitoring features not available in the free version. It is called Watershed, and it also allows you to manage who has access to the broadcast.

Where would you use this technology? The possibilities are endless. You could broadcast a storytime, author visits, interactive book reviews, and regional and statewide conferences. Many libraries have

limited travel budgets, and this type of streaming technology enables staff to attend conferences and events without incurring travel expenses. It also provides an option for patrons who for various reasons are not able to be present.

Other video streaming services include Justin-tv.com, Mogulus .com, Stickam.com, and Blogtv.com. They all offer the same types of features as Ustream.tv. Some focus more on individuals videocasting their lives. Take a look and see which might be the best fit for your program and events.

Some video streaming hosting services have a corporate focus. They are not free but offer a higher quality of product. One such service is AudioVideoweb.com. It has a large, inexpensive set of tools with which you can create your own Internet broadcast channel. It offers month-by-month billing, so you can test it out first without entering into a long-term contract. Other features are real-time statistics so you can monitor the audience, a chat component to use for advertising, a remote presentation tool, and 24/7 technical support.

Videowhisper.com provides software that you can install on your own server to broadcast your own video streams. Its Live Broadcast interface is geared toward people who want to create programs. Live Broadcast allows you to create a channel and stream video using a simple Webcam and microphone. You can see a viewer list, update title and show descriptions, and chat with viewers in real time.

The Live Video Watch interface is designed for viewers who want to watch and participate in the chat session. This is becoming more popular at library conferences and is called a "backchannel." This is where people who are in the audience post online comments about the session in real time as the speaker presents. It can add tremendous value to a session and really captures the experience of a presentation. We have experimented with this at a Library Camp at the Allen County Public Library using Twitter, and I have been impressed with the thoughts and comments from audience members. This technology also has a dark side, and I have seen people post snide comments while the speaker is presenting. A code of conduct that outlines expectations on posts in the chat portion of the video stream can help you prevent such a problem. Live Video Watch requires that visitors sign in for the session.

The third interface that Videowhisper.com provides is "straight video streaming." The viewer is not required to sign in, and there is no interactive element. It comes with a Joomla module and a WordPress

widget. This interface might require some technical expertise to install, and there is a free download trial version. If you are comfortable installing Linux, Apache, MySQL, and PHP, then this product is definitely worth a look. If you are not comfortable with them, then start with Ustream.tv.

Post-production is where we add the titles, captions, credits, fades, edits, sound effects, and more. It is also when we compress our videos and/or save them in different media formats and where we upload them to the Internet so we can reach our audience. We have covered several online video galleries in this section and ways to insert your videos into your blogs and Web sites. We also covered various streaming video sites that allow you to stream a real-time presentation that others can view from their computers. In the current economy, this allows staff and patrons access to training, talks, lectures, conferences and many other events, as they happen, without the cost of travel, thus greatly increasing their ability to attend and participate in outside events.

►4

MARKETING

- ► **Get the Word Out**
- ► **Create a Story**
- ► **Develop a Brand**
- ► **Form a Simple Marketing Strategy**
- ► **Use Social Network Aggregators**

Musicians have managers, artists have gallery owners, and authors have publishers, but if you are a one- or two-person production team you're going to have to go it alone. Reluctance to market your own work is common, but you created this work with an audience in mind. If you don't advertise and promote it, then your patrons will never discover it.

► GET THE WORD OUT

Who, what, where, and how: To whom are you marketing? Is it a specific patron demographic? What are you marketing? Is it the facilities, services, new material, staff? Where/what is the context? Are you presenting this from the patrons' point of view or from the organization's? How are you going to construct the message? Will you use romance, conflict, humor, or drama?

This example of a question/answer process will help you design your advertising campaign:

Q: What are you marketing?
A: We want people to come and use our library for free WiFi.
Q: Who are you marketing to?
A: We want to attract people who want to connect to the Internet through WiFi with their laptop.

Q: Where do you want them to go?

A: A specific department or library location, such as the library café.

Q: Whose experience are you trying to capture?

A: We are going to present this from a patron's point of view.

Q: How? What emotional mechanism are you going to use?

A: We are going to create a conflict and have the library be the solution to that conflict. Creating a conflict and either having library staff or the service resolve the crisis sends the message that we are here to help and your problems can be solved at the library.

▶ CREATE A STORY

A boyfriend and girlfriend are trying to decide where to go so that they can both connect to the Internet. One argues to go to a local coffee shop, but the other doesn't want to because the coffee shop charges for access and they can't afford it. The conflict lingers until one of them resolves it by saying, "Hey, we could go to the library. They have free WiFi." Humor is injected with the other person's response: "And they have a café so we can now afford to get a cup of coffee!"

This story has a beginning, a middle, and an end. It creates tension that is resolved by the library. The characters' frustrated and angry state is transformed when they realize the library is a solution that works for both of them. It is a subtle way of sending a message rather than beating the viewer over the head with the Used Car Salesman approach: "Come on down, folks, for all the free WiFi you can get at Crazy Eddy's Library."

No matter what the quality of your production, substantive stories will resonate with the viewer. The stories that you tell will express your professionalism, values, and services. Stay with the basic themes common to all good stories: comedy, drama, romance, and tragedy. If they were good enough for Shakespeare, you can probably still get some mileage out of them.

▶ DEVELOP A BRAND

Over time you will have a collection of works. So how are you going to market, promote, and share? Think about branding your collection. This branded term will be used every time you reference your video collection. As an example: "Check out the latest videos at 'The Vault.'"

The Vault is the brand. Why brand? It creates an identity for your collection. It makes it easy for people to talk about and remember, it is easily recognized, and it becomes part of the vernacular. It can be indexed, searched for, and found by Internet search engines. Branding simplifies promotion and marketing. If you are using other social software, stay consistent.

▶ FORM A SIMPLE MARKETING STRATEGY

In this section we are going to be signing up for a number of free social software services. If you have never used them before, don't worry. They're easy. Once you have signed up for one service, all the others are very similar. You will need to create a log-in name and password, and I'll explain one way to do this. You'll also need an e-mail address and to enter some personal information, such as first and last name. When you are registering for a service, some fields are mandatory sections that you must fill in and others are optional. As a rule I give the least amount of information that allows me to register.

Create a Unique E-Mail Address

Why create an e-mail address first? The social networking services you will sign up for will probably require an e-mail address.

Think about creating an e-mail account with the brand as part of the ID. We preface all our log-in IDs with the Allen County Public Library's initials, so, for the Video Gallery, the ID would be something like "acplgallery." Using the same user ID and password for all your social network accounts will help save your sanity. You will likely be collaborating with other coworkers and sharing this information, so security is probably not your top concern.

Quick Tip

Here's a low-tech approach when security is needed. Make a hard copy of all your user IDs and passwords on 3 × 5 cards, and keep them in a recipe box in a secure location. This way they can be referenced when needed.

Why not just use your personal work e-mail? Unless you are going to be working at this job forever, it is a good idea to separate this function from your daily correspondence. It will make transferring of responsibilities easier when the time comes. Having multiple e-mail accounts

might seem cumbersome, but I will show you some easy, free tools to help you manage these online services. Google and Yahoo both provide excellent free e-mail hosting services. (Hint: You might want to use Google because I will be using some Google tools later on in this chapter and it will be easier to have a Gmail account.)

Use a Video Hosting Service

You have created a video and want to share it with the world. How are you going to broadcast this video out onto the Internet? Which of the numerous free online video hosting services is the right one for you? Does it matter? The free video hosting market is extremely competitive, and not all services that start will survive over time. An example is Jumpcut.com. While the company is still serving video content, it is no longer allowing users to upload new content. YouTube and Flickr are good choices, because they are the market leaders and they require only minutes to create an account. YouTube and Flickr are also good because they have built-in social software that allows you to share your video with others. Vimeo.com (popular with video professionals because of its higher quality of video streaming), blip.tv, and Metacafe are other favorite hosting services.

Your hosting site needs to have a channel RSS service that alerts your audience when you upload new material. This way viewers can subscribe to the channel to see your latest creations. This is a new marketing technique because people's searching behaviors are changing. The expectation is that information should be pushed to them rather than them having to actively retrieve it. This is important because now you are going to be in the business of building an audience using some of the new social networking software tools.

Use Social Networks

Your goal is to be wherever your audience is. Who is your audience? Sometimes it is staff and other times it is patrons, and social network sites are popular ways that both groups receive information. As in the physical world, you want to be located in a high-traffic area to increase the chances of being discovered.

Do you need to have multiple accounts/channels to accommodate your different audiences? It will cost only a little time at the beginning to set up virtual spaces to cater to different groups. Even if you don't use them immediately, they will be available when you're ready. It is better to have and not need than to need and not have. This being

said, there is no rush to go out and register for every free piece of social networking software available. Building an audience is not going to happen overnight, so be patient.

Blogging is a good place to start. You can embed your newly created videos within the blog, and you also have a platform where people can leave comments about your work. Blogs come with RSS feeds that allow your viewers to easily subscribe. Free blogging services such as WordPress and Google Blogger are great places to start, but "hosted" services will give you certain other freedoms.

With "hosted" services you can create your own domain. Domain names are another important branding element. It has to be simple and memorable. If you work at a small library, it is probably going to be easier to create an auxiliary domain that complements your primary domain without ruffling too many feathers. If you are at a large organization, this option may not be available to you. A hosting service like Inmotionhosting.com comes with a suite of tools that you will find useful and is well worth the $9.00 per month.

Blogs are modular by design; this basically means that they don't come with everything you need. This is actually good because you probably don't know what you need at this time. As you learn, you can add functionality to the modular design by installing plug-ins. Plug-ins are nothing more than programs that you install to give your blog greater functionality. If you are still wrapping your head around the idea of modularity, just think of Lego blocks. Each block is equivalent to a plug-in, and you can use blocks/plug-ins to add new functions as needed to your blog.

I have found Wordpress to be the blog that more consistently meets my needs. I tried Blogger but went back to Wordpress.

Next, create a Facebook and a Twitter account and start collecting friends. Look for online community groups that you can join. In the library world we are accustomed to patrons coming to our location, but this is reversed in the virtual world. Your job is to find your audience in this space and assist them in discovering you.

What is the value of creating Twitter, Facebook, and Flickr accounts? There are a couple of reasons. Just like in the real world, you want to be in a location that has a lot of traffic, because it will increase the chance that your work will be discovered and you will increase your audience. The other reason is that people have their favorite ways to receive information. Your goal is to be wherever there is an audience.

Plug-Ins

There is a plug-in for just about every function that you can imagine. Some are the perfect solution, and others are not. These are some of the ones I use:

▶ **Embedded Video** is a WordPress plug-in that allows you to embed videos directly into your blog from a wide range of hosted sites. This is attractive because you won't need a plug-in for each video hosting service that you use.

▶ The **ShareThis** plug-in lets your visitors share posts with others. This is useful because your visitors will help generate traffic to your site.

▶ The **Google Analytics** plug-in gives you incredibly detailed statistics about who is coming to your blog and what they are viewing. You can track visitation over time and see which posts are most popular. The charting software shows if traffic is increasing or decreasing.

▶ Also try out **Embedr** to share your entire collection, the **Twitter** tool to crosspost from either Twitter to WordPress or from WordPress to Twitter, and **Askimet** to protect your comment section from being attacked by spam.

Digg and StumbleUpon are two examples of another type of social networking service that will help you promote and share your latest video creations. Digg and StumbleUpon are Web discovery tools that allow users to add your content to their sites and to comment on the content that is submitted. It is easy to join the community. Just create an account and become a submitting and voting member.

Members can vote on submitted links, and these votes are how link relevance is measured. This is appealing because it puts the power in the hands of the voting members rather than an algorithm. Think of it as a democratic Google search engine.

Use these services to submit and tag your videos. These services expose your videos to those who have the same interests and tastes. The ShareThis plug-in will allow your audience to easily StumbleUpon or Digg—or a number of other options—your site directly from your blog.

To test the idea of marketing and promoting through the Web, I experimented with uploading a video to Vimeo and watched the hit count. After a week it had stabilized at about 31 views with the last 3 days of the week having no views at all. I then wrote a blog post about the video and crossposted on my Facebook, YouTube, Flickr, Digg, and StumbleUpon accounts. The results in the next two weeks were 86 views on Vimeo, 96 views on YouTube, 31 views on Flickr, and someone blogged and commented on the video.

Do your own experiments with social networks. They will help you understand where your audience is viewing your work and can give you guidance with your future marketing efforts.

▶ USE SOCIAL NETWORK AGGREGATORS

So you have signed up for every social network service under the sun, and you are now confronted with managing them in a way that does not consume your every waking hour. Fortunately, there are tools to help.

On the Mac platform I have been impressed with Socialite (formerly EventBox). Because it has a single desktop client that I can use to manage Facebook, Flickr, Google Reader, Twitter, and RSS feeds, it is a very elegant solution. Its $20.00 price is well worth the investment. You can try it for free for 15 days, so it won't cost you a thing to check it out.

A large number of Web sites promise to aggregate your social networks, but most fall short. After trying half a dozen, I like FriendFeed the best. What is attractive about FriendFeed is that it has a Google gadget so that it can easily be embedded in an iGoogle page.

Given the endless possibilities and combinations of services available to manage social networks, here's how I do it. I use one iGoogle page. iGoogle offers what Google calls "social gadgets." On my iGoogle page I embed the gadgets for Google Reader to manage all the blogs that I subscribe to; FriendFeed to manage all my social networking subscriptions; and Gmail to manage my e-mail.

Google Reader also allows you to create folders for sorting your feeds and blogs. One way to start is to create three folders: Must Read, Read, and Later. Because this gadget is about reading and disseminating information, this simple structure works for me. I did create one other folder, called Interest, where I place nonwork-related blogs.

Despite all your hard work creating professional and creative videos, without marketing, no one will know about them. This chapter covered several useful online video hosting services, Web sites, blogs, and social networking sites and tools that you can use to market your videos. Now you're ready to start spreading the word about your library and your library videos.

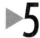

5

BEST PRACTICES

▶ Watch Library Videos on YouTube
▶ Follow Some Practical Advice
▶ Use Movies as Inspiration

Sharing and collaborating are fundamental to the library profession. Take some time and look at what others have created. It is a great way to become inspired and is a treasure trove of ideas. I often go to YouTube and search for "Libraries," "Library," and "Librarians" and see what pops up. There is always something new and I always find myself thinking, I wish I had done that. To see what the Allen County Public Library is up to, go to www.youtube.com/askacpl; to see my latest projects, go to www.youtube.com/tscrobinson.

▶ WATCH LIBRARY VIDEOS ON YOUTUBE

Here is a short list of YouTube videos that I find inspiring. You can view them on the channels provided or by doing a search of the title (full links are included on the wiki associated with this book):

- ▶ "Librarian": The video production on this work is amazing (www.youtube.com/user/HauntedLove).
- ▶ "Librarians Lay Down the Law": This video takes a humorous look at the Dewey Decimal System (www.youtube.com/user/evilkingdedede).
- ▶ "Monk Needs Help Opening a Book": There are a couple of versions.
- ▶ "Books I Will Not Read": This was created by Gerard Saylor, Director of the L.D. Fargo Public Library, Lake Mills, Wisconsin (www.youtube.com/user/LDFargoLibrary). He puts a great spin on the classic book review by telling you about books he will never read (see Figure 5.1). Gerard does something else—he is completely

honest. This makes the video entertaining, and it comes across as a conversation rather than a lecture. In creating a series, he has given his viewers a reason to return.

▶ Figure 5.1: Gerard Saylor Giving a Hilarious Book Review

- ▶ "Ninja Librarian": This video deals with patrons who make too much noise (www.youtube.com/user/letterboxmedia).
- ▶ "Between You and Me": This was directed by Patryk Rebisz. This is not a library video, but it is an amazing example of what can be done with a still camera and stitching together images to tell a complex story in under five minutes. This video inspires me, and I hope it will inspire you to do the best work you can no matter what tools you have.
- ▶ "Library Limbo": This takes a fun, light-hearted look at a library. I love the style and the thought that were put into this production.
- ▶ "No Cookies in the Library—Classic Sesame Street": What makes this video outstanding to me is its dialogue, timing, and delivery.
- ▶ "The Wizard of Oz—A Tale of Library Circulation."
- ▶ "Mr. Bean Library."

▶ FOLLOW SOME PRACTICAL ADVICE

Creativity is something you should practice every day. I carry a notebook with me everywhere I go. It is the perfect tool for writing and

Sean's Survival Tips

▶ **The story must always come first**. There are thousands of great ideas, but you need to form them into scripts that tell stories.

▶ **Create a log line**. This is a short summary of your story. Here is an example:

> This is a story about a New York cop who, with his wife and kids, gets accidentally caught in a bank with terrorists on Christmas Eve. He must stop the terrorists from blowing up the building and stealing all the money while protecting his family.

▶ **Create a title**. It is easier to write when you have the title of the work in your mind.

▶ **Scripts generally have three acts**. Act one is the beginning. It needs to instantly capture the attention of the viewer and hold it. It also establishes the setting and context. Something must push the character into action. Act two is when the tension builds and the audience is not sure how the story will turn out. Act three is when the story is resolved and the characters overcome the obstacles that have been placed before them.

▶ **Stories can have a moral theme that flows throughout the work—** love conquers all, good triumphs over evil, friendship is more valuable than possessions. If you are having trouble writing the script, think back to the moral theme.

▶ **Characters need to be well defined and compelling**. The audience needs to be able to relate to them. Beginning with a stereotype is an easy way to develop a character quickly. Costuming and location both play a large role in character definition.

▶ **Understand the visual details that will advance the story**. For example, clocks can be used to show the passage of time. Characters biting their nails shows anxiety. Write a list of all the visual images you want to capture.

▶ **Audio and sound effects can contribute greatly to the overall quality of the production**. Some examples are doors opening and closing, the footsteps as you walk down a corridor, the click of fingers on a keyboard. Think about the common background sounds like traffic and birds, and incorporate these elements into your video.

▶ **Create unexpected situations**. Even if it is only a twist on a worn storyline, there is nothing more gangrenous than predictability.

▶ **Plan everything you can in advance, and leave nothing to chance**. The more you prepare, the happier you will be with the final product.

▶ **Strive to be innovative**. Look for new ways to excite, entertain, and educate.

▶ **Constantly learn, experiment with, and explore new video techniques**. There is so much that can be achieved simply through investigating lighting and camera angles.

▶ **Have fun**. If you enjoy what you are doing, it will come through in the video.

drawing. I can collect my thoughts and ideas in one place. Sometimes I just make notes, and other times I collect words or story ideas or sketch scenes that might be part of a future video.

Observation, curiosity, and a desire to tell a tale or express an emotion are the ingredients with which my thoughts and ideas seem to grow. I spend lots of time just thinking, imagining new storylines, and envisioning ways to capture these ideas.

The foundation for any video or film is the script. In Hollywood it is the script that is marketed first. Even before a producer or director becomes involved there is the script and writer. You don't need special lighting and fancy video cameras to make a good film, but no amount of special effects and "A list" actors can save a bad story. Two thumbs with faces and a good script will make a good video.

On Writing Well by William Zinsser (Harper, 1998) was for me a transformative guide for writing nonfiction. The lessons and examples in his book easily translate to fiction. I have recently been reminded of Mark Twain's amazing book, *The Adventures of Huckleberry Finn.* If you are interested in writing great stories, then read great authors. To understand the genius of these writers, pick any sentence from their novels and try to improve upon it. You will notice right away that each word has been picked with care. Emulate this behavior, and your stories that once floundered awkwardly will suddenly start coming to life. Stories are built carefully, one word at a time.

Another author I want to mention is Janet Evanovich. In a recent interview I heard her talk about her creative process. She storyboards all her novels before sitting down to write. This gives her work a very cinematic feel.

Most people can't sit around with their feet up, thinking. We all have constraints on our time. I offer my survival tips for those of you who are trying to squeeze something else into an already full schedule.

▶ USE MOVIES AS INSPIRATION

Nothing is more inspiring than watching a great film. These are some of the movies that have had an impact on me throughout my life:

- ▶ *Cinema Paradiso,* directed by Giuseppe Tornatore (1988)
- ▶ *Dreams,* directed by Akira Kurosawa (1990; everything by this director is amazing)
- ▶ *My Neighbor Totoro/Tonari no Totoro,* directed by Hayao Miyazaki (1988)

▶ *Apocalypse Now*, directed by Francis Ford Coppola (1979)
▶ *Life Is Beautiful/ La vita e bella*, directed by Roberto Benigni (1997)
▶ *The Hunchback of Notre Dame*, directed by Wallace Worsley (1923)
▶ *City Lights*, directed by Charlie Chaplin (1931)
▶ *Memento*, directed by Christopher Nolan (2000)
▶ *Blade Runner*, directed by Ridley Scott (1982)
▶ *The Thin Red Line*, directed by Terrence Malick (1998)

I am sure that you have your own list of favorite movies that you think are great. Deconstruct them by looking at camera angles, composition, and lighting. Study how the director sets up a scene, and copy the editing techniques that you like. All this knowledge will help when you start to film.

You cannot second-guess what your audience is going to like and what will be popular. This is such a creative process that my recommendation is to create for yourself and follow your heart. At the end of the day, that is all that really matters.

►6

MEASURES OF SUCCESS

▶ **View YouTube Statistics**

▶ **Use Google Analytics**

Counting program attendance, circulation, and patrons is second nature to us as a profession. We like to measure and know how things are running. We are looking constantly to change, adapt, and provide the best experience for our patrons. There are some really great tools out there that will help you see the success of your videos. In this chapter I will describe two of the tools that I use to measure who is watching—YouTube's statistics and Google Analytics.

▶ VIEW YOUTUBE STATISTICS

Let's take a look at the statistics you can get from your YouTube account. You need to log in to get this information. In the top right-hand corner of YouTube's homepage is the "Sign In" link. Click on it and you will see the screen in Figure 6.1.

In the middle of the screen to the right you will see a link called "Insight." Click on it to go to a really nice breakdown of your viewer demographics. The screen in Figure 6.2 shows you where in the world you are having the greatest impact.

I want to drill down into the data and specifically look at the United States. I do this by clicking on the "Views" tab on the top left-hand side of the screen in Figure 6.2. This brings up the regions by state where the video has been watched (see Figure 6.3), and we can look at different data over different time frames. Highlight a state and click on it, and you will see specific information about that state over varying time periods (see Figure 6.4).

All this information helps you measure the effectiveness of your videos. You can see where the demand is and begin to start creating vid-

▶ Figure 6.1: Sean Robinson's YouTube Account Screen Showing Statistics

▶ Figure 6.2: Insight Screen Provides Detailed Statistics

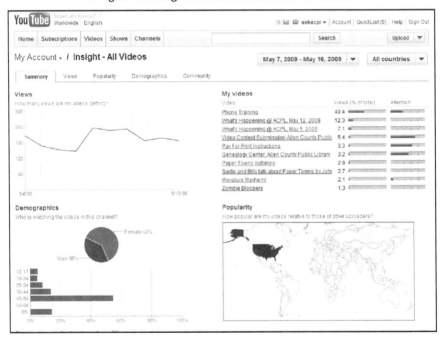

eos to meet that need. In Figure 6.4 we can see that our weekly "What's Happening" videos are popular, along with the "Pay for Print Instructions."

If you are embedding your video in a blog or a Web page, then you will need another tool to analyze your Web traffic—Google Analytics.

▶ Figure 6.3: Regional Statistics

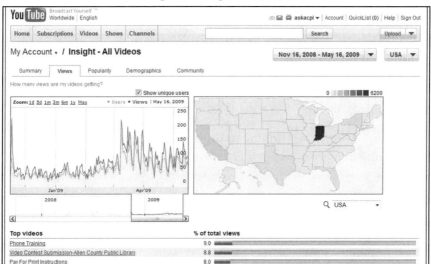

▶ Figure 6.4: State Statistics with Date Ranges

▶ USE GOOGLE ANALYTICS

I have been using Google Analytics (www.google.com/analytics) for the past six months on both my Web site and blog. Google has a nice video tutorial that takes you through all of its features.

First, create a Google Analytics account. Then, follow these steps to add Google Analytics to your self-hosted WordPress blog:

1. Find, download, and uncompress the Google Analytics plug-in.
2. Copy the uncompressed files to /wp-content/plugins/folder.
3. Go to your WordPress dashboard → "Plugins" and activate the plug-in.

Add your blog or Web site information into Google Analytics:

1. Log in to Google and click "My Account" and then the "Analytics" link.
2. In the top right-hand corner is a drop-down menu called "My Analytics Accounts." Pick "Create New Account."
3. Fill out the information about your site and give it an account name (see Figure 6.5). You will then be queried to provide contact information and accept a user agreement.

The next screen is the JavaScript tracking code. Copy this code and save it, as you will need to embed it into Web pages that you want to

▶ Figure 6.5: Configuration Screen for Google Analytics

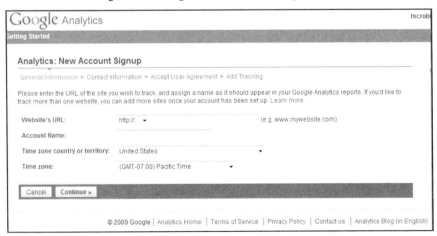

track and copy it to your WordPress plug-in. If you need it later, you can find this tracking code from your Google Analytics site. Go to Google Analytics Help and click on "Getting Started." Then choose "Where can I find my tracking code from within my Google Analytics account?" The video on this page is especially helpful.

To add JavaScript to your plug-in:

1. At your WordPress dashboard, go to "Options" → "Google Analytics."
2. Paste your Google-generated JavaScript into the available text field and click on the "Update" option.

Figure 6.6 shows the dashboard view. This tool provides many of the same statistics you are able to retrieve from YouTube, but these are specific to your blog or Web site.

If you do not have a hosted WordPress blog and you are using wordpress.com, you can go into your theme and edit your footer.php file. Add your code before the </body> tag.

▶ Figure 6.6: Dashboard View

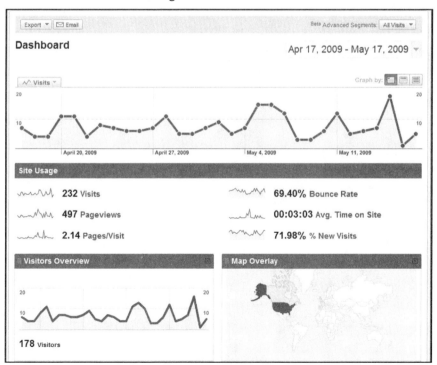

If you have a Google Blogger blog, here are the instructions from Google Analytics Help. In order to place the Analytics code on all of the pages in your Blogspot domain, simply insert the code before the closing tag in the template. Analytics will then be able to track both the post pages for your blog and your homepage. To begin using Analytics to track visitors to your blog, follow these steps:

1. Sign in to your Blogger account.
2. Select the blog you'd like to track, then click "Settings" from the **Manage** options.
3. Edit your template.
 - ➤ Classic Template Users select the "Template" tab.
 - ➤ Layouts Users select the "Layout" tab.
4. Select the "Edit HTML" tab.
5. Scroll to the bottom of the code.
6. Find the "</body>" tag, which usually appears toward the end of the code in the template.
7. Paste the Analytics tracking code just above the </body> tag.
8. Click "Save Template."
9. Click "Republish" to update your live site.

It is important that you are able to justify your video time and expense and show how effectively you are reaching your audience. There are many tools to examine the effectiveness and reach of your videos. In this chapter, we covered two of these tools, including what information you can gather from them and how they can be used.

▶

RECOMMENDED READING

▶ BOOKS

Artis, Anthony Q. 2007. *The Shut Up and Shoot Documentary Guide*. Burlington, MA: Focal Press.

Begleiter, Marcie. 2010. *From Word to Image: Storyboarding and the Filmmaking Process*, 2nd edition. Studio City, CA: Michael Wiese Productions.

Beiman, Nancy. 2007. *Prepare to Board! Creating Story and Characters for Animated Features and Shorts*. Burlington, MA: Focal Press.

Chandler, Gael. 2009. *Film Editing: Great Cuts Every Filmmaker and Movie Lover Must Know*. Studio City, CA: Michael Wiese Productions.

Glebas, Francis. 2008. *Directing the Story: Professional Storytelling and Storyboarding Techniques for Live Action and Animation*. Burlington, MA: Focal Press.

Hanke, Jeremy. 2009. *Greenscreen Made Easy: Keying and Compositing Techniques for Indie Filmmakers*. Studio City, CA: Michael Wiese Productions.

Jones, H. Frederic. 2002. *How to Do Everything with Digital Video*. Berkeley: McGraw-Hill/Osborne.

Kenworthy, Christopher. 2009. *Master Shots: 100 Advanced Camera Techniques to Get an Expensive Look on Your Low-Budget Movie*. Studio City, CA: Michael Wiese Productions.

Levelle, Tony. 2008. *Digital Video Secrets: What the Pros Know and the Manuals Don't Tell You*. Studio City, CA: Michael Wiese Productions.

Mascelli, Joseph V. 1998. *The Five C's of Cinematography: Motion Picture Filming Techniques*. Los Angeles, CA: Silman-James Press.

Maschwitz, Stu. 2007. *The DV Rebel's Guide: An All-Digital Approach to Making Killer Action Movies on the Cheap*. Berkeley: Peachpit Press.

O'Steen, Bobbie. 2009. *The Invisible Cut: How Editors Make Movie Magic*. Studio City, CA: Michael Wiese Productions.

Phillips, William H. 1999. *Writing Short Scripts*. Syracuse, NY: Syracuse University Press.

Tumminello, Wendy. 2005. *Exploring Storyboarding* (Design Exploration Series). Clifton Park, NY: Thomson/Delmar Learning.

Van Sijll, Jennifer. 2005. *Cinematic Storytelling: The 100 Most Powerful Film Conventions Every Filmmaker Must Know.* Studio City, CA: Michael Wiese Productions.

Videomaker. 2007. *Videomaker Guide to Video Production*, 4th edition. Burlington, MA: Focal Press.

▶ WEB SITES

Animation Forum. Available: www.animationforum.net/forum/index.php (accessed January 14, 2010).

Ask.com. "Making Digital Videos—Shooting, Editing and Sharing Digital Videos." Available: http://desktopvideo.about.com/od/videoprojects/u/makingvideos.htm (accessed January 14, 2010).

Brickfilms.com. Available: http://brickfilms.com/index.php (accessed January 14, 2010). This site and its community are dedicated to brickfilming—making stop motion animation with LEGO or other bricklike elements.

"A Brief Audio Guide for Stop-Motion Movies." Available: http://lowweek.free.fr/content/Audio%20Guide%20v1.1.pdf (accessed January 14, 2010). Actually, a very good guide to audio editing in general.

"Indy Mogul—DIY Filmmaking." Available: www.indymogul.com (accessed January 14, 2010).

"Shooting Better Video." Available: http://courses.iddl.vt.edu/DEDCM001/index.html (accessed January 14, 2010). An online, non-credit minicourse from Virginia Tech.

"A Videographer's Guide." Available: www.surveillance-video.com/videographer-nov-2009.html (accessed January 14, 2010). Offers many techniques and tips.

Videomaker—"Make Better Video for YouTube." Available: www.videomaker.com/youtube/ (accessed January 14, 2010).

INDEX

Page numbers followed by the letter "f" indicate figures.

▶

ABOUT THE AUTHOR

Thomas Sean Casserley Robinson has worked in the library technology field as a network specialist and IT manager for the past 17 years and is currently the head of Bibliographic and Information Technology Services. He has worked at the Allen County Public Library in Fort Wayne, Indiana, since 1994. He wrote a contributing article, "Learning 2.0 at the ACPL," that was published in the *Library Technology Report* "Web 2.0 and Libraries Part 2: Trends and Technology" by Michael Stephens. Sean co-authored the "Unified Communications for Public Libraries" study with Garrett Myers and has done consulting for Willard and Princeton public libraries.

He is a winner of the Information Today InfoTubey Award for the "Reference Zombies," video in 2008, which was also a finalist for the Thomson Gale Librareo Award in 2007, and with Kay Gregg, he has created a number of well-known library videos, including the iACPL series, the "Conversations" series with a number of influential people in the Library realm, and his new video "Vade Mecam." Sean also speaks on topics ranging from emerging library technologies to the impact of social software in libraries.

Sean blogs at www.tscrobinson.com and drawn.bluedei.com.

Sean lives in Fort Wayne, Indiana, with his wife Susan and their two dogs and one cat.